The Avant-Garde: A Very Short Introduction

VERY SHORT INTRODUCTIONS are for anyone wanting a stimulating and accessible way into a new subject. They are written by experts, and have been translated into more than 45 different languages.

The series began in 1995, and now covers a wide variety of topics in every discipline. The VSI library now contains over 500 volumes—a Very Short Introduction to everything from Psychology and Philosophy of Science to American History and Relativity—and continues to grow in every subject area.

Titles in the series include the following:

AFRICAN HISTORY **John Parker and
 Richard Rathbone**
AGEING **Nancy A. Pachana**
AGNOSTICISM **Robin Le Poidevin**
AGRICULTURE **Paul Brassley and
 Richard Soffe**
ALEXANDER THE GREAT
 Hugh Bowden
ALGEBRA **Peter M. Higgins**
AMERICAN HISTORY **Paul S. Boyer**
AMERICAN IMMIGRATION
 David A. Gerber
AMERICAN LEGAL HISTORY
 G. Edward White
AMERICAN POLITICAL
 HISTORY **Donald Critchlow**
AMERICAN POLITICAL PARTIES
 AND ELECTIONS **L. Sandy Maisel**
AMERICAN POLITICS
 Richard M. Valelly
THE AMERICAN PRESIDENCY
 Charles O. Jones
AMERICAN SLAVERY
 Heather Andrea Williams
THE AMERICAN WEST **Stephen Aron**
AMERICAN WOMEN'S HISTORY
 Susan Ware
ANAESTHESIA **Aidan O'Donnell**
ANARCHISM **Colin Ward**
ANCIENT EGYPT **Ian Shaw**
ANCIENT GREECE **Paul Cartledge**
THE ANCIENT NEAR EAST
 Amanda H. Podany
ANCIENT PHILOSOPHY **Julia Annas**

ANCIENT WARFARE **Harry Sidebottom**
ANGLICANISM **Mark Chapman**
THE ANGLO-SAXON AGE **John Blair**
ANIMAL BEHAVIOUR
 Tristram D. Wyatt
ANIMAL RIGHTS **David DeGrazia**
ANXIETY **Daniel Freeman and
 Jason Freeman**
ARCHAEOLOGY **Paul Bahn**
ARISTOTLE **Jonathan Barnes**
ART HISTORY **Dana Arnold**
ART THEORY **Cynthia Freeland**
ASTROPHYSICS **James Binney**
ATHEISM **Julian Baggini**
THE ATMOSPHERE **Paul I. Palmer**
AUGUSTINE **Henry Chadwick**
THE AZTECS **David Carrasco**
BABYLONIA **Trevor Bryce**
BACTERIA **Sebastian G. B. Amyes**
BANKING **John Goddard and
 John O. S. Wilson**
BARTHES **Jonathan Culler**
BEAUTY **Roger Scruton**
THE BIBLE **John Riches**
BLACK HOLES **Katherine Blundell**
BLOOD **Chris Cooper**
THE BODY **Chris Shilling**
THE BOOK OF MORMON
 Terryl Givens
BORDERS **Alexander C. Diener and
 Joshua Hagen**
THE BRAIN **Michael O'Shea**
THE BRICS **Andrew F. Cooper**
BRITISH POLITICS **Anthony Wright**

David Cottington

THE AVANT-GARDE

A Very Short Introduction

OXFORD
UNIVERSITY PRESS

Great Clarendon Street, Oxford, ox2 6DP,
United Kingdom

Oxford University Press is a department of the University of Oxford.
It furthers the University's objective of excellence in research, scholarship,
and education by publishing worldwide. Oxford is a registered trade mark of
Oxford University Press in the UK and in certain other countries

British Library Cataloguing in Publication Data

Data available

ISBN 978-0-19-958273-0

Printed and bound by
CPI Group (UK) Ltd, Croydon, CR0 4YY

Contents

List of illustrations

Introduction

Question: What do these have in common: hair design, art and artists, property lettings, fashion, letterboxes, jazz music, bicycle saddles, fast cars, consulting engineers, T-shirts, and lifestyle coaching? Answer: in a recent trawl by this author on the internet, particular instances of these all shared the designation 'avant-garde', either as descriptions of them or as part of their brand names. This range the use of 'avant-garde' is striking. And for anyone interested in contemporary culture, and in the ways in which it constantly changes, it is worth noting, I would suggest, for three reasons. First, because clearly it is a buzzword, a term that is used because of its current power to bestow on certain things and practices in the cultural marketplace an instant 'up-to-dateness' that seeks to distinguish them from their competitors. Second, because it is apparently empty of meaning beyond this very 'up-to-dateness': what it appears to point to is no specific quality other than the value our (western?) culture places on newness, on contemporaneity. And third, because if the term 'avant-garde' is as readily available as this, to signal such newness, then it has already become a cliché—has already been 'co-opted' for an *expectation* of the very qualities of *un*-expectedness that the 'new' is supposed to bring, and that make it new; which makes it something of a contradiction in terms.

But of course the word 'avant-garde' itself does have meanings, if we for a moment separate it from these specific usages and consider it on its own: it is French, and a military term. This is a strange origin for what has become one of the commonest in the cultural vocabulary of the English language. How then, you might ask, did it cross the English Channel and acquire such ubiquity? And does this history help to explain the ways in which newness, up-to-dateness, is a key value in western societies?

These questions are central to the concerns of this book. But there are others also that a consideration of the term 'avant-garde' raises, particularly with respect to one of the above instances of its use: that of art and artists, because this term is one of the two most important and influential concepts of all those that are used in discussing, and shaping, the history of modern art (the other one is 'modernism', which we'll come to shortly). I am using the term 'art' here in its most general sense, to refer to the range of cultural practices of the modern period, since both the social grouping to which the term 'the avant-garde' refers, and the concept of 'avant-garde' itself, are applicable across 'the arts'. However, as we shall see (and for reasons that we shall explore), it was in the field of fine art that the cultural grouping we call 'the avant-garde' first emerged, and it is this field too, as I shall argue, that has played the largest role in shaping the concept's meanings and its history. For over a hundred years it has governed critical and historical assessment of the quality and significance of a fine artist or a work of fine art—to the extent that, *if these have been judged to be 'avant-garde', or to belong to 'the avant-garde', then they have been worthy of consideration.* If not, then (with very few exceptions) they have not, and neither critics nor historians have paid them much attention. In short, modern art is and has been very largely whatever the 'avant-garde' has made, or has said it is. Steadily, this understanding and valuation of modern art has become extended to *all* of 'the arts': design, literature, music, theatre, architecture, film, and photography all

seem to be evaluated in terms set in the same way. And further: in this field of the arts, the connotations of up-to-dateness that the term 'avant-garde' has carried have been commonly associated with the quality of radicalism: that is, of a degree of newness that is fundamental, implicitly critical of the status quo—and also implicitly political in this criticism. In short, avant-garde arts and radical politics have been often assumed to be closely related; and specifically (but again implicitly) those of the left.

Yet in the field of cultural history very little work has been done, despite the ubiquity and strategic importance of the term, to explore *why* 'the avant-garde' carries so much authority, or how it came to do so, or how membership of this exclusive 'club' has been decided, or whether this association with leftist politics is warranted. What is more, the term remains a slippery one, and is often used in a slipshod way. What is the relation between 'the avant-garde'—that is, the social grouping (the 'club')—and 'avant-garde' qualities in a work of art (or design, or literature, architecture, or film)? What is the relation, too, either between the 'avant-gardes' in the different arts, or between the avant-garde qualities that they display—are these equivalent? And where does 'avant-gard*ism*' come in? Last but surely not least, now that contemporary art seems to have broken all taboos and is at the centre of a billion-pound art market, *is* there still an artistic 'avant-garde' and if so, what is the point of it and who are the artists concerned? Is the annual Frieze Art Fair in London 'avant-garde', or the Venice Biennale, or the Booker Prize competition, or the arthouse film festivals around the world? If so, what—or who—makes them so? For all its ubiquity in writing about modern culture, none of these key questions has yet been adequately answered; the concept, in all its variations, has largely been taken as given. So this book proposes to answer these questions too, and to do so in a way that puts the 'avant-garde' in the wider context of the development of western modernity, capitalist culture, and the global impact of both.

Definitions and distinctions

We need first to make some grammatical distinctions, because part of the problem with the uncertainties of its meaning is that in common usage, even within the restricted field of art history, the term slips confusingly between adjective and noun (as in the italicized sentence in the second paragraph above, in which the adjective 'avant-garde' refers to qualities, and the noun 'the avant-garde' to a notional community of self-consciously aesthetically radical artists). A related distinction is that between this (concrete) noun 'the avant-garde' and the abstract noun 'avant-gard*ism*', which summarizes those qualities and bundles up the commitment to them into an attitude and even an ideology. Distinguishing between these three will help us to understand the term better, because historically (to put it, for now, at its simplest) the adjective and its related abstract noun preceded the concrete noun. That is to say, the qualities of the arts that we call 'avant-garde'—art practice (in its broadest sense) that sought to say something new in its time, to acknowledge the implications and potential of new (including popular, mass) media, to stake a claim for aesthetic autonomy, or to challenge prevailing values— emerged, in ways we shall explore, in the mid-nineteenth century, and were bundled up into an attitude and an aspiration that we call 'avant-gardism', before there were enough aesthetically radical artists to make up that community which we call 'the avant-garde'.

We need also to make a further distinction, this time of definition: between an understanding of 'the avant-garde' as referring to some artists but not all—to those, that is, who belong(ed) to that community of aesthetically radical artists—and a notion of art *itself* as 'avant-garde'. The first of these is our current understanding, and the one that governs the wide-ranging use of the epithet with which I started. But the second is important too: not only because it preceded our current one historically, but because it relates the idea of 'avant-garde' directly to notions of historical progress, of what used to be called 'the ascent of man',

4

which have made up the guiding narrative by means of which western societies have made sense of the experience of historical change, for the last 250 years (until, perhaps, very recently, as I shall suggest). It is no accident that the word 'avant-garde' is French, because it was the French Revolution of 1789–94 that, more than any other event in European history, brought about that rupture with the past on which the consciousness of change and of 'modernity' were founded. And it was in France in the years after the restoration of the monarchy in 1815 that social theorists across the political spectrum most profoundly questioned the legacy of the revolutionary years and, finding the resulting political and social settlement wanting, sought ways of improving upon it—of replacing the fossilized hierarchy of the monarchical regime with a social order more respectful both of individual rights and collective identities. One of the most influential groups on the left of this political spectrum was gathered around Count Henri de Saint-Simon who, shortly before his death in 1825, elaborated a model of a state-technocratic socialism in which society would be led by a triumvirate of professions: the artist, the scientist, and the industrialist. Of these, the artist would be the 'avant-garde'—and the term was first used in a non-military context, in this way, by Saint-Simon and his group. For them, artists were 'the men of imagination', and this revaluation of imagination, as opposed to a reliance on reason that had brought society to its present impasse, was characteristic of much of the social theorizing of the time.

Within twenty years of this Saint-Simonian coinage, however, the use of the term had proliferated in other directions than that of politics alone. By the 1850s wider use of 'avant-garde' had spread to the cultural arena, with writers in particular being described with this epithet—but in ways that as yet kept close to the military sense and, in the case of its best-known early coinage, that of the poet Charles Baudelaire, were also clearly negative. In his private notebook of the early 1860s (published posthumously as *My Heart Laid Bare*) he wrote bitterly of 'the Frenchman's passionate predilection for military metaphors': 'the poets of combat. The

littérateurs of the avant-garde.' 'This weakness for military metaphors', he noted, 'is a sign of natures that are not themselves militarist, but are made for discipline—that is to say, for conformity.' Baudelaire's coinage of the term here is interesting not only for its disdain, but also for the implication that *not all* writers ('littérateurs'), not all literature, was 'avant-garde', but only some—this marks a shift from the Saint-Simonian idea of 'art (in its widest sense) *as such* as avant-garde' to a new sense of 'an avant-garde *within art*'. It marks the emergence of our modern understanding and use of 'avant-garde'.

An avant-garde within art

The factors were many that contributed to the entrenchment, by the mid-nineteenth century, of the belief in progress as the motor of western societies: the decline of religious belief; the awareness, in the wake of the French Revolution, of the human capacity to bring about fundamental change, for better or worse; the acceleration of fundamental material and social change consequent upon the Industrial Revolution of the same period—above all, the consolidation of the capitalist system into a global marketplace. In their incendiary *Communist Manifesto* of 1848, Marx and Engels summed up, in a trenchant paragraph, the unprecedented dynamism of this system:

Constant revolutionising of production, uninterrupted disturbance of all social conditions, everlasting uncertainty and agitation distinguish the bourgeois epoch from all earlier ones. All fixed, fast-frozen relations, with their train of ancient and venerable prejudices and opinions are swept away, all new-formed ones become antiquated before they can ossify. All that is solid melts into air, all that is holy is profaned and man is at last compelled to face, with sober senses, his real conditions of life and his relations with his kind.

The need of a constantly expanding market for its products chases the bourgeoisie over the whole surface of the globe. It must nestle everywhere, settle everywhere, establish connexions everywhere.

The encroachment of commercial values on all aspects of life that was consequent upon this consolidation of capitalism included all aspects of the cultural practices of its participant societies. This provoked some artists to seek to escape the conventions, the commodification, and the complacencies of an 'establishment' art in which those values were inscribed. Writers such as Baudelaire, painters such as Manet found their very existence as members of a materialistic, status-seeking bourgeoisie problematic—their distaste for such values not only alienating them from existing social and artistic institutions but also generating a deeply felt sense of psychic alienation. This treble alienation, it has been argued, was the well-spring of avant-gardism in our modern understanding of it, as an avant-garde within art but separate from other artists and their conventions.

Yet there were other factors. Just as it is no coincidence, as I have noted, that the very term originated in France, neither is it that the modern sense of the term emerged in Paris. For this city was regarded at the time as the cultural capital of Europe, with an unrivalled cultural bureaucracy, art schools, and career structure for artists. Aspirant artists and writers and musicians flocked to it from all over the world in the later nineteenth century in the hope of grasping the glittering prizes that Paris, above all other cities, promised. And their aspirations were matched by those of the French governments from mid-century on, who fostered a diversity of cultural outlets marketing a range of artistic products. Putting into practice the theories of the Saint-Simonians, successive governments encouraged the arts, much as their present-day equivalents promote the 'creative industries', to meet the demands of an increasingly varied and expanding middle-class clientele with a multiplicity of cultural styles and products. Emperor Napoleon III was the first, setting up in 1863 a 'Salon des Refusés' (Exhibition of Rejected Artists) that offered an alternative to the standards of the Academy-run, 'establishment'-oriented official annual Salon, comprised of paintings that its jury had just rejected. The initiative met, however, the combined resistance of

the art hierarchy and of the conservative tastes, not only of the official Salon's clientele, but of the public, too: it gave that public a licence to indulge in uproarious and ribald ridicule of 'bad' art—which it did in its thousands, crowds flocking to the Salon des Refusés to mock its exhibits. Thus, despite the efforts of the state to foster the growth and broadening of the market for culture, most of the aspirant artists, writers, and musicians were unsuccessful in gaining a career, instead finding their paths to fame choked by their own numbers and obstructed by continuing social and economic privilege, and conservatism of taste. Forced to the margins of the art world, they sought alternative channels of advancement and terms of recognition, exhibiting or performing together in informal groupings; artists, writers, and musicians networking between their multiplying café-based milieux to promote and contest new ideas and practices, about which the writers (and sometimes the others) wrote in a proliferating range of ephemeral little magazines. Thus, by default as much as by intention, through government commercial policy as much as in rejection of commercial values, a community of non- or anti-establishment artists, writers, and musicians gradually cohered in Paris towards the end of the nineteenth century, making works in their respective media that reflected their aesthetic marginality—that were in consequence often experimental and often, also, expressive of that treble alienation noted above. We shall explore the consequences of this development in the next chapter, but we should note here that this kind of work, created in this increasingly cohering community, is generally described by cultural historians as 'modernist', and that we need first to make a further distinction: between 'modernist' and 'avant-garde'.

Avant-garde and modernism

I suggested earlier that 'modern art is and has been whatever the "avant-garde" has made, or has said it is'. In truth, it would be more correct to say 'modern*ist* art', rather than 'modern', because,

alongside 'avant-garde', it is the term and the concept of 'modernism' that has been most important for the shaping of the history of western culture over the last century and a half. For historians of the arts, these two terms are, if not different words for the same thing, then integrally related. In most histories of most of the arts, modernism has been taken to be what the avant-garde has created, and reciprocally, the avant-garde is significant and distinguishable for the modernist qualities that it has explored and developed. But we need to be clearer about their relation than this, since the two words stand for two different *kinds* of concept, and whilst their connotations are close, there are some crucial differences between them. As the discussion so far has shown, the avant-garde was (and perhaps still is, as we shall see in the final chapter) a formation, a network of identifiably distinct social groupings based on those common ('avant-garde') cultural attitudes and practices that I have outlined. Modernism, on the other hand, refers to the ways in which artists of all kinds have articulated their experiences of modernity, whether they have been in avant-garde groupings or not. We can take 'modernity' to designate any, or any combination, of perhaps three possible kinds of experience. The first is the experience of those unprecedented social, political, demographic, and technological changes that have characterized especially the western world (and those others with which it came into contact) since the early nineteenth century: factory production, urban growth, mass social and political movements, new forms of transport, and so on. The second is the experience of new or rapidly changing means of communication, such as photography, mass circulation newspapers, mass literacy, telephones, radio, and cinema. The third is the interior mental, psychological states of mind that can be related to those changes: loss of community, uprootedness, decentredness, alienation, new group identities, and the like. For artists in all media, these experiences were the matrix from which they produced their imaginative creations, symbolizing and articulating their response to modernity most often through an engagement with the characteristics specific to their chosen media, and an exploration

9

of how its conventions had been, were being, called into question by aspects of that modernity. This is, broadly, the kind of work to which historians of all cultural practices and media have given the name 'modernist'. But the artists pursued this, for the most part, from within the cultural and social spaces of the avant-garde, whose characteristics and attitudes also informed their creations.

As an illustration of this relation and this dynamic, we might explore Georges Seurat's painting *A Sunday Afternoon on the Island of La Grande Jatte* (Figure 1). Painted in Paris between 1884 and 1886, it represents a popular, if largely middle-class, leisure-spot in the Seine, downriver from the city centre. As such it relates to the subject matter of Impressionism, which often depicted just such scenes of urban relaxation. So does the way it is painted: its brushwork is broken up, as are those paintings, into little individual touches of paint, the better to capture the kaleidoscope of colours that animate such an outdoor scene on such a sunny day, and convey the sensations of the freshness of the weather. But there are three significant differences: first, Seurat's brushstrokes, applied as dots, do not seem informal, spontaneous, and rapidly applied like, say, Monet's or Renoir's, but systematic, dispassionate, and almost machine-made in their consistency— and the technique by which they were applied was careful and considered, each colour being added according to a quasi-scientific calculation of the quality of light in sunlit and shaded areas of the scene, and the relation of this to the existing ('local') colour of grass, clothes, sky, and so on. This quality of the paint gives the picture surface a screen-like appearance (a not unreasonable simile, since the individual spots of varied colours were apparently intended by Seurat to merge, when seen from an appropriate distance, and thereby capture the perceived colours of the scene more accurately—and this is the same principle behind the pixelations of a colour TV screen). Second, while Impressionist paintings are easel-sized, easily carried by the artist to and from the site (and suitable for the apartment walls of their middle-class purchasers), the *Grande Jatte* is huge, around 200 by 300

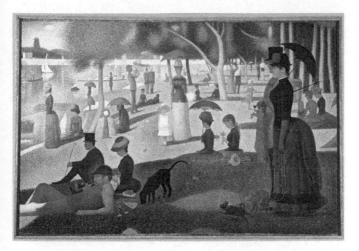

1. Georges Seurat, *A Sunday Afternoon on the Island of La Grande Jatte*, 1886

centimetres or seven by ten feet, therefore clearly painted in the studio (if after outdoor sketches and notations) and equally clearly public, as opposed to private, in its scale and implied destination. And third, as against the loosely brushed informality and animated appearance of the figures in many Impressionist paintings, and the ordering of their scenes in depth 'artlessly' via the roads or rivers that they often depict, Seurat's figures are stiff and wooden, almost doll-like in appearance, disposed in a series of planes parallel to the picture surface that recede behind each other towards the horizon in a clearly calculated, seemingly artificial way. The consequence is to convey a feeling of emotional distance between viewer and subject matter, to suggest perhaps that modern city life had by the mid-1880s become de-individualized, its inhabitants stiff and isolated from each other, unspontaneous and robotic. Whether or not this was indeed Seurat's intention, some such inference is at least possible, and in this respect the picture seems to offer an articulation of, or commentary on, one response to 'modernity', and to do so in a way

11

that innovates in both its painting technique and its representational style. Moreover, it marks a difference from Impressionism in all of these qualities, a fact which earned this style the name of 'Neo-Impressionism'. And yet, at the same time as being highly experimental in this technique, in its scale and in its frieze-like composition that stresses the surface of the picture the *Grande Jatte* stands in relation also to much older art, such as early Italian Renaissance frescoes, as well as to the then-contemporary public murals of leading mainstream artists such as Puvis de Chavannes.

In terms of my above distinction between 'modernism' and 'avant-garde', we can say that the aesthetic properties and the interpretative possibilities of the *Grande Jatte* are modernist, in that they articulate an experience of modernity, and do so with means that engage with, call attention to, and experiment upon the conventions and material properties of painting: the way the paint is applied, the planar composition, the screen-like surface, the stiff frieze-like figures all call those conventions into question. But the way that these properties and possibilities are deployed are avant-gardist, insofar as they are motivated by an awareness of aesthetic positions, oppositions, and alternatives within the field of Parisian art-making: of the cultural spaces in that field in which the picture was painted and exhibited, and the relation of these contexts to other spaces. For, first, the *Grande Jatte* stands clearly against Impressionism in technique, style, and scale (as well as in the name 'Neo-Impressionism' accepted by Seurat for its style). Second, it was exhibited not (as Impressionist paintings by Monet and Renoir in particular increasingly were by the mid-1880s) in up-market private galleries decked out to look like the private apartments of the well-to-do, or in the annual salons of the art establishment, whose selection committees or 'juries' excluded the most innovative entries, but in the makeshift temporary marquees of the new, juryless and resolutely populist Salon des Indépendants, erected for the purpose in the Tuileries Gardens. This exhibition society, founded in 1884 by Seurat's friends and, as its title suggests,

opposed to mainstream, academic art (indeed, sympathetic to the politics of anarchism), was where amateur 'Sunday painters' as well as members of the emergent avant-garde would show their work over the next several decades. Thirdly, because the scale of the picture could be (and was) seen as in itself a declaration of support for a public role for painting, in the face of its steady market-led privatization, and its likeness to contemporary mural decorations could be taken as an implicit mark of a commitment to the decorative—even the civic—role of painting: a depiction of modern life that placed it on a par with the scenes from French history that many such murals presented. In sum, the *Grande Jatte* is modernist as regards its aesthetic practice, and avant-garde in its inscription of extra-artistic strategies of challenge, group closure, and social, as well as aesthetic, distinction.

If the two terms are closely related, they are not coextensive. That is, not all modernisms need originate in the avant-garde, or have self-consciously avant-garde properties. There may exist isolated individual artists expressing their experience of modernity in an innovative interrogation of the conventions of their chosen medium without membership of, or even contact with, the collective of the avant-garde. These artists have, though, been customarily categorized as 'naive' for precisely the lack of self-consciousness of the significance of their innovation that such membership provides (the 'Douanier' Henri Rousseau in Paris around 1900–10, and Alfred Wallis in St Ives, Cornwall, in England around 1930, are examples). Nor does modernism necessarily entail experimentation with *new* forms in any given medium; it could be enough to recuperate traditional but outmoded, or no longer valued, forms and conventions, and to juxtapose those against current practices. This was done across the western world, and across the arts, at the start of the twentieth century, by those artists who turned to the folk arts and vernacular traditions of their national cultures: composers such as Béla Bartok or Ralph Vaughan Williams, painters such as Natalia Goncharova, poets such as William Butler Yeats. For the most part, however, a

13

modernist work of art (a painting, a poem, a musical composition, a film) will have been created within an avant-garde grouping or, more loosely, in awareness of the networks of the avant-garde formation and of their aesthetic concerns—for it is difficult to see in most cases how, other than with this membership or awareness, its creator would have had access to modernist qualities and concerns (that there have been so few 'naive' artists contributing to innovation in art proves this 'rule'). And in consequence, the character of its engagement with the experience of modernity and the means of its representation will have been shaped by its position in, or in relation to, that formation.

But the avant-garde formations of different media emerged at different times, at different speeds, and as a result of different factors that were specific to them, if related to shared ones, and they were not all equally significant for the incubation of modernist culture in their respective fields; it mattered greatly how complex were the *material and institutional requirements* of each practice. We should take account of these differentials, if we are to understand how the avant-garde developed through the twentieth century. We shall consider this question more fully in the following chapters, but the example of literature, and its development in nineteenth-century France, will indicate in outline some of the specific factors involved.

Differential developments

Baudelaire's disdain, noted above, for writers whose 'avant-gardism' was a mark of conformity to rules and formulae of writing suggests that, by the 1860s, the field of literary production in France was already divided between those he was criticizing, who wrote in such a formulaic way for an increasingly mass readership (the rapid growth of which reflected the spread of literacy in that country), and those, like Baudelaire himself, for whom the practice of literary writing—especially poetry—was a vocation, a mark of attachment to higher values than those of commerce. It was in the

fifty years from the mid-1830s, in fact, that writing became industrialized in France: the number of novels, volumes of poetry, and plays published had increased by 50 per cent by the mid-1880s. Of these, novels grew most in that period, by nearly 400 per cent, while the number of plays did not change and that of poetry volumes declined by 25 per cent. As the cultural historian Christophe Charle suggests, these differentials register an increasingly clear divorce, over those decades, between the financial success achieved by novelists and the literary consecration achieved by poets and playwrights. Yet between 1860 and 1890 the number of writers in France doubled, as—like aspirant painters and sculptors—aspirant *littérateurs* flocked to Paris, drawn by its reputation as the cosmopolitan literary capital of the world. Such a population of writers needed the means to support itself materially; the novelist Gustave Flaubert may well have aspired, as he put it, 'to live as a bourgeois and think as a demi-god', but this still required the means of a bourgeois. It was, crucially, a pair of material developments of around 1880 that helped to furnish these means. The first was a relaxation, in 1881, of the laws governing the French press, as the Third Republic, founded only a decade earlier, began to feel less threatened by the monarchist right. This removed the dissuasively large financial deposit required of anyone who wished to publish a magazine, as well as the censorship which had severely constrained press freedom. It was therefore less expensive, and less risky, to publish a wide range of opinions, whether political, literary, or both. The second development was a technological revolution in newspaper publishing, which saw rotary web-offset printing introduced. Invented in 1865, this allowed rotary-fed printing on both sides at once, of paper that from the mid-1870s could be made from wood-pulp more cheaply than from the rags that until then had provided its raw material, and the resulting relinquishing of now-obsolete letterpresses. These could be bought by those wishing to print the magazines that they could now afford to set up. The consequence was a flourishing of the culture of 'little magazines' in Paris; in the pre-1914 decade nearly 200 of these circulated in the city, most of

them literary in orientation, and most functioning as mouthpieces for the many 'isms', each with its own aesthetic position, that proliferated from the late nineteenth century. Although the profits were minuscule if any, the job of writing for these 'petites revues' provided training and work, and some money, for young writers while they waited for their (as they hoped) inevitable lionization.

We can infer from this brief history that the emergence of a distinguishable cultural collective such as a literary avant-garde from a scattered population of individual aspiring writers requires a set of material developments, specific to literature (that is, different from—if overlapping with—those specific to other media such as fine art) and to the city in question, which can enable this population to make a living, of sorts, *as* avant-gardists; and that it requires also a collective sense of independence from the mainstream, such as that fostered by the little-magazine culture, of a strength sufficient to bring a collective identity into being. These could be called the necessary conditions for the emergence of the nucleus of a cultural avant-garde.

There is a difference, however, between these conditions for its emergence and those for its consolidation—that is, for its sustainable, self-reproducible existence as a cultural (and perhaps counter-cultural) formation. Paris was the first city anywhere to generate such conditions. As we shall see later, these were partly external to the formation itself and partly internal, and they provided a model for others to follow, or to depend upon, or to differ from. The history of the cultural avant-gardes through the twentieth century includes all of these alternatives, which later chapters will explore; here, we should note their trajectory across that century, and into our present one.

From consolidation to co-option

Seurat's painting *La Grande Jatte* is not only an example of an avant-gardist work; it was also one of the founding works of the

emergent artistic avant-garde of Paris, a manifesto for a new style whose avant-gardism was signalled in its very name, Neo-Impressionism positioning itself as by definition distinct from Impressionism—at once a step beyond and a continuation of it. The decade in which it was painted, the 1880s, saw an increasing use of the term 'avant-garde' to describe the Neo-Impressionists, as the conditions necessary for the emergence of the formation came into existence: a supporting network of exhibition and sales outlets, of which the Salon des Indépendants was the hub, and a collective identity as a distinct grouping, underpinned by a growing number of paintings in the Neo-Impressionist style, and by the support of a cohort of sympathetic critics and gallerists who helped the painters to establish and disseminate its aesthetic principles across western Europe. But the consolidation of this formation was the product of external factors as well. Historians have noted that one of the salient features of modern capitalist societies, professionalization (or the division of labour within the middle class as their economies matured from a base in manufacturing to one that included knowledge and service industries), began to gain momentum from the 1880s: doctors, lawyers, academics, architects, accountants, and others who made a living from the monopoly control of such specialist knowledges, established professional societies and criteria for accreditation around this time. Artists, of all kinds and in all media, were no different, and the artistic professions were guarded and gradated by a proliferating hierarchy of qualifications, prizes, and honours, to which social as well as technical status was attached.

The avant-garde formation, too, was shaped by this professionalization. As we shall see in the next chapter, however, this was an *alternative* professionalism, fundamental to which were three features. The first was the elaboration of energetically promoted and contested aesthetic principles that were not only different from, but often opposed to, those of the mainstream. The second was the emphasis upon, and development of, equally independent technical means and craft inheritances. The third

was the mutual recognition of their common aspirations that was signalled by the epithet 'avant-garde' itself. The international character of this alternative professional identity was also crucial, especially in the field of fine art, for the numbers of foreign would-be fine artists who flocked to Paris—and the lack of art-career success for most of them—at once gave this avant-garde population a critical mass sufficient to warrant the collective identity, and enabled an extraordinary pan-European dissemination of its energies in the immediate pre-First World War years. Between 1910 and 1914, in every city with any cultural dynamism, small groups of aesthetically radical artists, in all media, sprang up like mushrooms in a box overnight, creating a network of exchanges of ideas, cultural products, and their producers (and using every vehicle for these exchanges including the new technologies of the time, such as the telephone, the telegraph, and the automobile) whose hectic pace was unmatched until the internet revolution of the late twentieth century.

This network was an informal one—that is, it followed no established rules or protocols, but made these up for itself as it forged its links and means of communication, and most of these were snuffed out by the First World War before they could be formalized. The generation that created it was dispersed—in many cases killed—in that catastrophe. But it had acquired enough momentum and material reality to enable a post-war generation to build upon it; and from the middle of the war years until the coming to power of Nazism in the early 1930s it did so. However, this 'second generation' of the avant-garde came of age with the example, and the traces of the networks, of the first generation before it, and in consequence it behaved differently. Where the years before 1914 had been ones of consolidation, those between, roughly, 1917 and 1933 were ones in which the formation was shaped by a triangular field of economic, political, and social dynamics that led to what we might describe as its institutionalization. One such dynamic was the widespread determination to reject the values that had led to the recent

catastrophe, to build a new and better world in which its repetition would not be possible. A second was the momentum of a rapidly developing international and monopoly capitalism, on the model of which cultural avant-gardists developed the informalities and rudimentary procedures of the pre-1914 network into a more formal set of protocols. The third dynamic was that of the Russian revolution of 1917. For a network of self-consciously technically radical artists in all media, whose alienation was (as I have suggested) a triple one, aesthetic, institutional, and social at one and the same time, the example of the Bolshevik revolution opened a political dimension to their situation and their aspirations.

We shall explore these dynamics in depth in Chapter 2, for the tensions between them very largely shaped the growth of the inter-war avant-garde. It was still, at that stage, a predominantly European formation. But the rise of Nazism led many artists, in all cultural media, to leave Europe from the early 1930s. Many found their way to a New York that was already in the middle of a hectic period of assimilation, and contestation, of European cultural modernisms, and the result was a reprise, of sorts, of the Parisian avant-garde formation of the pre-war years, with the flourishing of isms and aesthetic positions, magazines, dealers, and critics, all positioning themselves in one way or another vis-à-vis European modernism and its newly disembarked representatives. There were two differences, however, and together they characterized 'the New York scene' as a continuation, to a degree, of that of the European formation. The first was the centrality of anti-Fascist politics in that decade, and its powerful attraction for—indeed, for many, politicization of—the city's avant-garde community, fostering much debate and cultural production around the question of allegiance to, or disagreement with, the model of Stalin's Soviet Union. The second was the fact of America's growing domination of international capitalism, which encouraged, indirectly but with much consequence for its contemporary artists, the growth of a network of wealthy collectors of modernist art, and patrons of modernist

19

culture. Initially their orientation was to that of Europe, as having already the reputation that made substantial financial investment in it fairly secure, but slowly this patronage extended to home-grown culture, including fine art. The foundation of the Museum of Modern Art in 1929 by three leading plutocratic women (Abby Rockefeller, Lillie P. Bliss, and Mary Quinn Sullivan) raised the status of both European and American contemporary art, providing a genealogy for selected avenues of experiment that was to prove highly influential in the decades to come.

Also unlike Paris and Europe in 1914, the US mainland was untouched directly by the Second World War, and its key industries benefited from the demands of the war economy, while its affluent classes were unable in wartime to find consumer goods on which to spend their money. With the coming of peace, the floodgates of the savings of millions opened on to a consumer market newly expanded by the shift from making cruisers to making Cadillacs, and among the beneficiaries of this was the market for contemporary American art. We shall explore in Chapter 3 the ramifications of the consolidation of this art market; we should note here, though, that it not only consolidated the New York avant-garde (and with it, given the power of the dollar, that of the whole western world) as a formation, but effectively co-opted it, for a dominant social class for whom the patronage of aesthetic innovation—suitably purged of political association—was a mark of cultural distinction. In this process, the Museum of Modern Art played a leading role, acting in conjunction with key critics and galleries, as well as several governmental organizations, to promote and support the work of the New York (and, by extension, American) artistic avant-garde not only in that city but around the world. It consecrated this avant-garde's achievements in terms which juxtaposed its (depoliticized) aesthetic freedoms with the political shackles of Soviet culture, as part of the American programme of 'Cold War' propaganda. Thus, ironically, it used for political purposes an Americanized modernism whose apparent autonomy, or independence from politics, was central to this very consecration.

The co-option of the avant-garde, and of avant-gardism, seemed then complete. It was a co-option summarized, in a way, by the Pop Art movement in America, which in the 1960s seemed, with few exceptions, content to share consumerism's values, and to borrow its sometimes tawdry glamour, blurring or testing the boundaries between modernism and consumer culture (in ways that Chapter 3 will explore), and its artists were rewarded by the ready patronage of nouveau-riche collectors who delighted in such art.

Did this co-option mark the end of a cultural avant-garde as an independent, critical, even oppositional formation in western societies? If the promoters of 'postmodernism', which in the 1980s was one product of the apparent capitulation to capitalist values, were to be believed, then the answer was largely yes. But they did not go unopposed; from within the supposedly co-opted avant-garde —fuelled on the one hand by the student protest movements of 1968, and channelled by the rise of modern art schools, on the other by the growing anger of the women's movement—emerged (or re-emerged) a politicized, critical energy which expressed itself in art that deconstructed its own co-option in a variety of ways. From the minimalism of artists such as Robert Morris and Donald Judd, through the 'land art' of the likes of Richard Long and Robert Smithson, and the conceptualism of Sol Lewitt or the Art & Language collective, to the institutional critique of Hans Haacke and the feminism of Judy Chicago, Mary Kelly, Carolee Schneeman, and a thousand other women artists, opposition to the marketization of contemporary art, or to its capture by museums, broke out wherever the latter held sway, across the world, like flaming oil well-heads signalling the existence of a vast reservoir of cultural imagination, whose potential for disruption of the smooth workings of capitalist culture seemed, through the 1970s, limitless. We shall consider this potential in some depth later. Was it a mirage, shimmering enticingly on the hot sands of a cultural desert, or was there—is there still—enough untapped, un-commodified imagination to drive a re-emergent avant-garde around the block at least one more time?

Chapter 1
Origins: emergence and consolidation 1820–1914

Avant-garde as politics

The extension of the concept of an avant-garde from military to political discourse was a product of the French Revolution and its aftermath. It was a revolutionary military newspaper that first coined this usage of the term: *L'Avant-garde de l'armée des Pyrénées orientales* appeared in 1794 in support of the Jacobin Terror of 1793, bearing on its banner the image of a sword engraved with the watchwords 'La liberté ou la mort' ('Liberty or Death'). It was in France in the years after the restoration of the monarchy in 1815 that, as I noted earlier, social theorists across the political spectrum sought ways of improving upon the associated political and social settlement, and one of the most influential groups on the left of this political spectrum was led by Henri de Saint-Simon. Shortly before his death in 1825, he elaborated a model of a state-technocratic socialism in which society would be led by a triumvirate of professions: the artist, the scientist, and the industrialist. Of these, the artist would be the 'avant-garde'. For the Saint-Simonians, artists were 'the men of imagination', and this revaluation of imagination, as opposed to a reliance on reason that had brought society to its present impasse, was characteristic of much of the social theorizing of the time.

Not just in France, however. Perhaps not coincidentally, the English poet Shelley, born in 1792 in the middle of the French Revolutionary years and supporter of its aspirations, wrote an essay 'Defence of Poetry' in 1821, the year before his young death, in which he asserted the social role of poets in avant-gardist terms, although he did not use the word: they were 'heralds', 'mirrors of futurity', and, in the phrase which has come down to us as perhaps his best known, 'the unacknowledged legislators of the world'. Published posthumously in 1823, the essay placed poets in such a leading social role as the Saint-Simonians did artists, because of their imaginative faculties. The difference between them was as striking, though. As the cultural historian Matei Calinescu has noted, the Saint-Simonians at one and the same time placed artists in the vanguard of society because of these faculties, and burdened them with a whole programme of social didacticism that contradicted the very freedom of that imagination. Calinescu suggested that this resembled the role that the artistic and literary doctrine of 'socialist realism' played in the Soviet Union of Stalin from the 1930s to the 1950s. We might update this by noting its resemblance, also, to the contemporary emphasis on the 'creative industries' in which artists in all cultural media are seen as important more for their contribution to the competitive position of their national economies than for the values of the imagination which they sustain and deploy. Shelley, on the other hand, gave no programme to poets for them to fulfil; rather, he emphasized in 'Defence of Poetry' that the imagination was in itself the highest moral quality and should be subservient to nothing else. In brief, as Calinescu notes, this difference was between two political principles that are polar opposites: those of authoritarianism and libertarianism.

It is, moreover, a difference that is, arguably, contained within the concept of 'avant-garde' itself, however it has been applied (whether as noun or adjective); a tension that runs through its very definition, between the radical nature of its separation from the mainstream of society, as a military avant-garde is separated

23

from the bulk of its army, and the aspiration that it inscribes to *lead* that army, that society. If it is a separate entity, on what terms does it lead, what is the relationship between it and its assumed 'followers'? As we shall see in later chapters, in some definitions and manifestations of it, 'avant-garde' means autonomy—complete independence from that mainstream—whether this is aesthetic, social, or political. In others, the emphasis is upon the leadership, on the qualities that give entitlement to guide the way to the future and on the means by which they will do so. But in all cases, the two emphases, the two poles of its meaning, coexist.

The Saint-Simonian coinage of 'avant-garde' as a characterization of the social role of art was at once aesthetic and political, because this was a period when the potential of aesthetics as a socially and politically restorative force—of its ability to bring harmony and unity to a still-traumatized nation—was widely perceived among social thinkers in France. It was the political character of the concept, though, that was first exploited. In the *Communist Manifesto* of 1848 Marx and Engels criticized Saint-Simonian and other related socialisms for their authoritarianism in trying to rally all sectors of society in unqualified obedience to the leadership of that triumvirate of artists, industrialists, and scientists mentioned above, and in so doing treating the proletariat, the downtrodden working class, as 'a class without any historical initiative or any independent political movement'. Instead Marx and Engels asserted the potential power of this class, ending their manifesto with the now-infamous peroration 'The proletarians have nothing to lose but their chains. They have a world to win. Working men of all countries, unite!' In place of Saint-Simon's triumvirate, they put the Communist movement: 'the Communists do not form a separate party opposed to other working-class parties', they declared; 'they have no interests separate and apart from those of the proletariat as a whole.' Thus, there was no Saint-Simonian hierarchy between them and the working class; they were simply 'on the one hand...the most advanced and resolute section of the working-class parties of

every country, that section which pushes forward all others; on the other hand, theoretically, they have over the great mass of the proletariat the advantage of clearly understanding the line of march, the conditions, and the ultimate general results of the proletarian movement.' Although Marx and Engels did not use the term, the concept of an avant-garde is clearly implicit here. Unlike that of the Saint-Simonians however, it was generated by those themselves whom it was its role to lead; unlike Shelley's poets, it had a programme, even if that programme was a function of its own distinguishing qualities.

The avant-gardist implications of the *Communist Manifesto* were not lost, in the decades that followed, on the socialist and anarchist movements then emerging across Europe, and especially in France. The Russian anarchist Peter Kropotkin published a magazine called *L'Avant-Garde* in Switzerland in 1878, and during the 1890s several Marx-inspired workers' parties in provincial France used the same title for their newspapers. But the term, and the concept, were most explicitly taken up, and developed into a detailed political strategy, soon after the turn of the twentieth century by Lenin, in Russia. In his polemical doctrinal pamphlet of 1902, *What Is To Be Done?*, he argued for the fashioning of his Social Democratic Party into 'the vanguard of the revolutionary forces' of its time. For Lenin it was crucial that this role was not simply asserted, but acted out in all of the Party's political work in projects that directed the workers and dictated a programme of action, and that as a result the Party was acknowledged by the workers as its political leadership. Three years later he extended this programme to literary activity: in an essay 'Party Organisation and Party Literature' of 1905 he condemned 'non-partisan literature' and 'literary supermen' and declared that 'Literature must become *part* of the common cause of the proletariat, "a cog and a screw" of one great Social-Democratic mechanism set in motion by the entire politically-conscious avant-garde of the entire working class.' If the designation 'avant-garde' had blurred a little, suggesting extension beyond the

Party itself, the priorities between aesthetics and politics were nevertheless clear.

Consumerism and its contradictions

It was not only the relation between aesthetics and politics that the concept 'avant-garde' brokered, however. In the context of a burgeoning mid-nineteenth-century capitalism, it also negotiated the interface between the arts and the changing experiences of modernity, especially in the city. As I noted earlier, those experiences included rapid growth in numbers of city-dwellers, the spread of factory production, the emergence of new means of communication, the proliferation of commercialized popular culture, and the burgeoning of capitalism's robust and voracious offspring, consumerism. The expansion of the capitalist marketplace noted by Marx and Engels found its prime representation in Paris, in the material, and increasingly visible, marketplace for consumer goods and commercialized entertainment. For integral with the city's artistic reputation was its renown as the capital of hedonistic consumption: of fashion in particular, but indeed of desirable goods of all kinds, and of their display as spectacle—in summary, we could say that Paris was the first 'spectacular city'. From the middle of the nineteenth century it led the world in the growth of the retail trades: the first city in which department stores were established, that were housed in palatial premises rivalling those of monarchs, and that expanded steadily in number and square metreage to dominate the consumer goods market in all sectors, from hats to hardware, by the First World War. This burgeoning of consumerism, of its modes and spaces, had an impact on cultural products as much as any others—on the making, performing or exhibiting, selling and buying and viewing and reading of the arts—as new audiences and new patterns of consumption created new demands. To take fine art as an example, these new demands included smaller paintings for city-centre apartment walls and more modest budgets, a wider range of exhibition venues, a broader spectrum of

styles to suit wider and increasingly less formal tastes. In the mid-nineteenth century, the art market was dominated by the huge annual state-sponsored exhibition known as the 'Salon', where scores of thousands of viewers jostled packed crowds to see up to 5,000 paintings lining walls from floor to ceiling, and where artists competed for the honours of prize-winners' medals and state purchases. By the turn of the century, the incapacity of this system to handle the growth in numbers, on both the supply and demand side, of this market was clear. It had led, on the one hand, to the proliferation of Salons (by 1903 there were four a year in place of one, the number of whose combined exhibits had risen to nearly 20,000), and on the other to a well-developed hierarchy of art galleries and dealers, as well as artists' associations, who provided viewing conditions more comfortable, less crowded, and more domestic in appearance than those of the public pandemonium that was the Salon. Their exhibition rooms were characterized by plentiful seating, uncrowded displays of art works, appropriate and harmonious decoration; all the accoutrements, in short, of their viewers' own private interiors, or those to which they aspired.

This 'privatization' of the art-viewing experience, and the broadening of its social constituency, not only brought art more fully into the consumer domain, blurring the distinction between the fine and the decorative arts. It also harnessed to the market's ceaseless demand for novelty the emergent aspirations of avant-gardism (as I put it earlier: to say something new, to acknowledge new, including popular, media, to stake a claim for aesthetic autonomy, or to challenge prevailing values). And vice versa: from the late nineteenth century, in Paris but, increasingly, elsewhere too, artists felt and responded to the market-driven demand for aesthetic innovation. Yet if this added to the dynamic potential of artistic avant-gardism, it also increased the tensions within the concept and the ideology it expressed: for 'avant-garde' was supposed to stand for a position *outside* of the (cultural and social) mainstream, independent of it (and leading it, as in

Saint-Simonian usage, or critical of it, as the multiplying marginal communities of artists were coming to be). As society, and social relations, came increasingly to be governed by the 'cash nexus' of the capitalist market, it had originally been, as we have seen, the imaginative faculties of the artist that had created both a space of respite from these and an alternative set of values with which to critique them. Thus, as art became steadily more integrated with what we now call 'lifestyle consumption', the term 'avant-garde' came to harbour a third tension, even contradiction, alongside those between authoritarianism and libertarianism, radical politics and aestheticist autonomy: a contradiction between the imperatives of consumerist innovation and the refusal of its values. We shall trace the ramifications and the implications of this contradiction in Chapter 3.

Before leaving the present discussion, though, it is worth noting that this particular contradiction was the subject of an influential analysis by the sociologist of culture Pierre Bourdieu, who proposed that what he called 'the field of cultural production' in modern western societies should be seen as structured by two opposing principles, rather like the positive and negative poles that structure a magnetic field. These two principles are those of 'heteronomy' (that is, dependence on outside forces) and 'autonomy' (independence of them): according to the first, a work of art or any other cultural product is valued according to the degree of its success in the commercial marketplace, which is a register of its popularity in quantitative terms. According to the second, it is precisely the *lack* of that commercial, quantitative success that confers on a work of art or any other cultural product a value that is recognized, not by the widest audience, but by those engaged in making similar work—in other words, by the smallest number, of a self-styled elite whose aesthetic values are opposed to, rather than congruent with, those of the market. The shape of the 'field of cultural production' itself is determined by the pull of these twin poles, as cultural producers are positioned by them, and take positions in response to them. We can discern clearly

here the tensions that I have identified within the concept of 'avant-garde'. Bourdieu situated this cultural field within a larger field, that of power (understood in its social, political, and ultimately economic dimensions), in ways that—as we shall see—help to clarify the significance, and the impact, of 'the avant-garde' on society and social relations at large.

By the last quarter of the nineteenth century in France, then, the modern concept of an 'avant-garde' of artists had gained some currency. It was not only separate in terms of its aesthetic principles and practices from the cultural mainstream, but self-declaredly ahead of it, oriented to the future and breaking new ground with its experimentations (and thus committed to an ideology of aesthetic 'avant-gardism'). It had also acquired a set of connotations that articulated the tensions between cultural practices and values on the one hand, and on the other a society increasingly dominated by those of the capitalist marketplace. At that point, however, this avant-garde community had barely begun to find its separate identity. Moreover, in the account of its history given here, the term 'artistic avant-garde' has so far been used both in a general, all-encompassing way, to refer to artistic media in the widest sense, including literature, music and theatre, photography and film, as well as fine and decorative art, and, more specifically, to refer to visual artists committed to experimental practices. Yet these media and practices each had their own communities within the larger avant-garde formation, and were shaped (as I noted in the Introduction) by different, if related, factors. We need therefore to explore in more detail the matrix from which they emerged, and the stages of their emergence, consolidation, and proliferation.

That matrix bound the literary and artistic fields, in particular, into close relation in late nineteenth-century Paris, for these two had been pre-eminent in Paris throughout the century, and they overlapped in the subculture of the little magazines that they shared (the artists often exhibiting in the magazines' offices, the

writers reviewing the art) as well as in the cafés in which they argued over their aesthetic enthusiasms. Yet there were differences in the nature both of their work and of its product that distinguished them. For one thing, artists needed art schools, and art schools fostered collective identities, whilst writers had no such specialist education *as* writers. In addition, the skills of the studio were both concept- and handicraft-based, resourced by mind and eye and hand together, unlike those of writing. Moreover, paintings and sculptures were unique objects sold to collectors, whilst novels and poems were available to anyone who could afford the price of a book. And art needed little more for its public dissemination than a wall or a floor to hang or stand it on, whilst writing needed publishers and printing presses and bookshops. Perhaps most importantly, not only was art well placed to represent a rapidly modernizing urban world—a 'spectacular city', as I termed it earlier—whose visual appearance was changing radically, but also, and conversely, it was perhaps uniquely challenged by the impact of that modernization. Its traditional role and status were threatened from one side by a proliferation of alternative technologies of visual representation (from photography to the cinema), from another by the proliferation of consumer products, including decorative art, and from a third by the steady replacement, across industry, of handicraft by machine manufacture. Visual artists within the emergent avant-garde thus found themselves possessed of a cultural medium that, on the one hand, was thrown into crisis by urban modernity, but on the other had unparalleled scope for engagement with the central features of that modernity. The recognition, partial though it must have been for each individual artist, of both the crisis and the scope led them variously to reflect upon the specificities of their medium, and its changing roles and potential. Increasingly, they explored the relation of painting to its image-making properties (what it meant to represent visual reality in paint as opposed to by other new means), to the craft skills that such representation traditionally required (as opposed to the mechanical processes of those new technologies), and of sculpture

30

to its objecthood (how it distinguished itself from other consumer goods).

All of these factors distinguished visual art not only from literature but also—in fact, even more markedly—from other cultural practices, such as opera or orchestral music (and to a lesser extent theatre) whose productions required substantial capital investment, and audiences who patronized them in sufficient numbers to be profitable, and which were held back from innovation by these constraints; as Alex Ross notes, in 1920s Paris a nineteenth-century support structure for music persisted, with composers still needing to make their names in the music Salons that were the equivalent of those in fine art. Film-making, too, proved prohibitively expensive, for at least the first two decades of its existence, for individual artists to embark upon without financial backing, with consequences for avant-garde film-making that we shall explore; only the Lumière brothers, who established their film-making around the turn of the century on a factory-production footing, were able to make good returns. Indeed, I would argue that in a modern world driven increasingly by mass mechanized production, the proliferation of consumer goods, and their spectacular display (from the late nineteenth century to at least the mid-twentieth) the above factors helped to make visual art, which felt the impact of these drivers most acutely, the dominant cultural medium of the modern age. But this position was crucially bolstered by the numbers of aspirant artists that flocked to Paris, the art capital of the western world, through these decades. At a rough estimate there were perhaps 3,000 fine artists in Paris who saw themselves as members of the avant-garde in around 1910, more than those active in any other medium (in some cases far more). Such numbers helped to make fine artists the key agents of the consolidation of the cultural avant-garde from its beginnings in the scattered population of marginalized artists in Paris. Perhaps more importantly for that formation in the longer run, they underlined fine art's pre-eminent role within it. Throughout the twentieth century,

time and again, avant-garde cultural producers in other fields can be seen to have started out as fine artists before moving to other media, or looked to the example of art for new departures in their own media, and adopted its experiments or adapted its innovations for their own purposes. For example, as regards the first, the earliest avant-garde experiments in film were made by two painters, Hans Richter and Viking Eggeling, who turned first to scroll-based explorations of the kinetic possibilities of abstract, geometric forms, before turning to film for the more effective and 'professional' presentation of these, in works such as Eggeling's *Diagonal Symphony* and Richter's *Rhythmus 21*, both of 1921. As an example of the second, the so-called 'ultra-modern' musical avant-garde groupings in New York in the 1910s were much influenced by two artists of the European avant-garde. The first was Futurist painter Luigi Russolo, author in 1913 of a manifesto *'The Art of Noises'*, inventor that same year of the 'Intonarumori' or 'Noise Intoner' that generated noises from which he made compositions, and as such a key pioneer in noise music. The second was former Cubist Marcel Duchamp, who was part of the New York formation from 1915, and who, with *Erratum musical* of 1913, a composition for three voices, was the first person deliberately to employ chance operations in music. (Duchamp made three sets of twenty-five cards, one for each voice, with a single note per card. Each set of cards was mixed in a hat; he then drew out the cards from the hat one at a time and wrote down the series of notes indicated by the order in which they were drawn.) Indeed Duchamp, and the exploration on his part and that of other visual artists such as Jean Arp, and Robert Rauschenberg at mid-century, of chance as a creative technique were of profound significance for a range of artists in other media. For chance composition was a means of calling into question, at one and the same time, the mythic status of artistic creativity, painterly craftsmanship and bourgeois rationality in general, and as such was attractive to all who shared an inclination to mock or critique conventional cultural assumptions. The Surrealists used chance, in all media from writing to film and photography, to try to

liberate the unconscious and thus make humanity whole again; the composer John Cage, above all, found both in the ironic wit and iconoclasm of Duchamp and the paintings of Robert Rauschenberg the model for many innovations that redefined the reach of 'music'. Cage's most notorious work, the 4' 33" of 1952, was inspired specifically, he later recalled, by Rauschenberg's all-white paintings of the previous year, which were intended to catch the accidental lights and shadows of their exhibition environment, much as Cage's piece caught the noises made during the duration of his note-less 'composition'.

It is largely for these reasons that visual artists have a primary—though by no means exclusive—place in this account of the history of the formation, and the concept, of the avant-garde, from its emergence from a scattered population of marginalized artists in late nineteenth century Paris to its most recent fortunes over a century later. The members of this population slowly came together in different ways and for different reasons, forming ties and common purposes that gave them a degree of collective identity by the time of the outbreak of the First World War. The process of this coming together is what we shall look at next.

Bohemia: life and/as art on the margins

> Bohemia, bordered on the North by hope, work and gaiety, on the South by necessity and courage; on the west and east by slander and the hospital.

> Henry Murger, *Bohemian Life*, 1849

> The present Bohemians of Paris...have ceased to steal fowls, change children...or to tell fortunes...The true modern bohemian is not the wild, wandering, adroit, unprincipled, picturesque vagabond, who has been the delight of the poet, the novelist and the painter for ages...yet he bears many points of resemblance...Although neither a gypsy nor a

> mountebank, he is wild and wandering, occasionally
> mysterious, often picturesque, and not seldom, I am afraid,
> unprincipled...In a word, the Parisian Bohemians of today
> are a tribe of unfortunate artists of all kinds—poets, painters,
> musicians and dramatists—who haunt obscure cafes in all
> parts of Paris, but more especially in Quartier Latin.
>
> Charles Dickens, *Household Words*, 1851

The figure of the bohemian has, for 150 years, played a large part in the fashioning of the image of the modern artist (and continues to do so today)—and its history is integrally related to, but crucially distinct from, that of the avant-garde, in ways that are illuminating to explore. The two characterizations cited here, one of the mythical country of Bohemia and the other of its (possibly equally mythical) inhabitants, were written at a key moment in its evolution, and together offer valuable insights into the qualities of both. Originally, neither was mythical—Bohemia was a part of the Austro-Hungarian empire in central Europe, a region comprising what is now the western two-thirds of the Czech Republic, and Bohemians were its inhabitants; in the early nineteenth century, the term came also to refer to central European Gypsies (Romany) and, given the peripatetic habits of this people, by extension to any nomadic types who lived at the margins of society and on precarious means (largely, their wits). As the processes of industrialization and urbanization increasingly displaced the rural poor of Europe from their settled communities, and as the abolition of Gypsy slavery in eastern Europe gave them the right to emigrate, growing numbers of these found their way to the mushrooming cities, to find marginal, low-paid employment—as street-porters, organ-grinders, ragpickers, knife-grinders, tinkers, errand-boys, the manifold little occupations of city streets—and to live in their most insalubrious quarters. Paris was not alone among western capitals in attracting such itinerant poor, but since its role as the European capital of culture made it a magnet also for aspiring

artists who were equally lacking in financial means or steady employment, and as the penetration of its cultural sphere by the values of the capitalist marketplace was perhaps more developed than elsewhere, there evolved in that city, as a negative product of both, a composite figure of the 'bohemian' that comprised two types: on the one hand the wild and unprincipled social outcast of Dickens's description—what the Romantic poet Théophile Gautier in the mid-1840s called 'cranky ruffians', 'frightful villains', 'hideous toads who hop in the mires of Paris'—and on the other (also in Gautier's description) 'foolish youth which lives somewhat haphazardly from day to day by its intelligence: painters, musicians, actors, poets, journalists, who love pleasure more than money and who prefer laziness and liberty to everything, even glory'. The revolution of 1848 that finally ended the French monarchy and ushered in the (brief) Second Republic enhanced this already myth-shapen composite in two further dimensions: with qualities of political radicalism and resistance to an integrated social role, and with those of the superior but crazed outcast artist. As is evident from the quote from Henri Murger (who made his reputation in shaping the myth, in a series of stories that were later the basis of the libretto for Puccini's opera *La Bohème*), this Bohemia was a poor, desperate place; as that from Dickens suggests, it had no fixed geographical location but overlapped with those districts of Paris where students congregated. And this provides the basis for another characterization of it: insofar as students were young (male) members of the urban middle class, historian Jerrold Seigel has argued that there was a close relationship between Bohemia and the bourgeoisie: 'Bohemia has always exerted a powerful attraction on many bourgeois, matched by the deeply bourgeois instincts and aspirations of numerous Bohemians', Seigel argues, suggesting in summary that 'Bohemian and bourgeois were—and are—parts of a single field: they imply, require, and attract each other.' He suggests that, on the one hand, descent into Bohemia was a rite of passage for such young men, who sought to sow their wild oats before taking up the obligations of a respectable career,

and on the other that the ambition of many Bohemians was to achieve commercial success and worldly renown, despite their affecting to disregard both.

It is tempting to see this Parisian Bohemia as the nascent avant-garde formation, and Bohemians as the first avant-garde artists, writers, and musicians. This would be a mistake, however, for two reasons. First, because Bohemia was too provisional an environment; it did not have the stable support structure, or the markers of a coherent collective identity, or the security of life, to amount to a formation. Second, because what Bohemia had to offer—independence from convention, freedom from bourgeois cares, a way of life itself as a work of art—was grounded in the marginalized locales of cafés in unfashionable, poor quarters; when commercialized entertainment appropriated these watering-holes, co-opting and professionalizing their informalities, the only alternative to acquiescence in this market takeover was invisibility and further degradation (in the decades that followed, all that was left of 'bohemia' and 'bohemian' was that connotation of a dissolute, 'artistic' lifestyle, but minus the poverty and the radical politics, with which we are still familiar today). And it was this very process of professionalization and marketing, occurring at the same time in the adjacent sector of cultural production—loosely, the 'art world'—that was bringing the avant-garde properly so called into being: an avant-garde defined around an opposition not so much to bourgeois life as to its artistic practices and institutions, and able to develop an identity that was constructed through a complex engagement with those commercial forces that threatened Bohemia's very existence.

Professionalization and artists

The process of professionalization that I described in the Introduction as one of the driving forces in the modernization of western capitalist societies included, as I noted, the artistic professions. Although fine artists in particular had long been

under the protection, and patronage, of the state—a status that was registered in a negative sense by the pejorative designation 'pompier' (literally, 'fireman') given by the avant-garde to the most conservative art, as suggesting that it was the work of state functionaries—the late nineteenth-century professionalization was also the privatization of the role of the artist. As Emperor Louis Napoleon III loosened the art world's links with the state from the 1860s, and successive Third Republican governments followed suit, fine artists themselves began to establish institutions to protect their interests and promote their work, and increasingly in an international arena. Impressionism, though initially regarded with disdain by most critics and art publics when it was launched in the early 1870s, was quite quickly (that is, by around 1880) seen to picture the leisure pursuits of a younger generation of both such audiences, and in versions of it that were shorn of its most challenging features (such as radically rough brushstrokes, too-luminous colours), became a point of reference for a wide range of 'middle-of-the-road' artists who distinguished themselves from the most conservative, pompier art by their adoption of its modern subject matter and its looser paint handling. The resulting common ground of style was so broad as to have little coherence—and indeed, whilst the artists who positioned themselves upon it did break, in doing so, from the conventions of academic art, what they had in common was less to do with aesthetic qualities (let alone aesthetic innovation) than with their opening-up of new sectors of the art market, and developing a network based on advantages of social connection, position, and wealth that stretched across Europe and reached, for the first time, across the Atlantic.

As art historians Robert Jensen and Béatrice Joyeux-Prunel have shown, this new, privatized, professional fine artists' network became established across Europe by the end of the nineteenth century. In Brussels, it was represented by the 'Cercle des XX' (Circle of the Twenty); founded in 1884, this sought to establish an elite institution for modern artists on the model of London's clubs,

while in London itself the New English Art Club, founded
two years later (and which was nearly named the Society of
Anglo-French Painters), sought to rally and support those English
artists who had trained in Paris and were oriented to its art world.
This network was effectively consecrated in Paris in 1890 by a
breakaway from the state-sanctioned Salon by some leading
artists including Rodin and Puvis de Chavannes to form a rival
Salon, that of the Société Nationale des Beaux-Arts (National Fine
Art Society), and this was followed through the next decade
by similar breakaways in Munich, Berlin, Vienna, and other major
cities. Since the common ground between them was little more
than their shared network and the action of secession from their
Academies, they became known as the 'Secessionists'.

An alternative professionalism

It was in opposition to this network of bourgeois fine artists, as
opposed to the authority of 'academic' art and its state-sponsored
but conservative and unfashionable ideas, that the artistic
avant-garde emerged in the mid-1880s. It was an opposition at
once aesthetic and social: aesthetic, in its substitution of a shared
and informed engagement with contemporary scientific theories
of how colours were produced from light, were mixed as pigments,
and were perceived by the human eye—and the innovations of
pointillist brushwork that this produced—for the empty rhetoric
of 'talent' and 'quality' that held together the widening circle of
middle-of-the-road Impressionism; social, in the Neo-
Impressionists' alienation from the networking of an elite for
whom social rank and affinities counted for more than canvases.
But this emergence, and this opposition, were driven, like the
Secessionists whom it opposed, partly by the dynamic of a process
of professionalization that by the first decade of the twentieth
century had reached even the cultural and social margins. By 1910
the population of artists in Paris who saw or found themselves to
be part of a cultural community that operated beyond the pale
of those sanctioned bureaucracies had grown, as I suggested earlier,

to number thousands and, crucially, included a substantial minority of foreign artists. These numbers and this international character gave it both a critical mass and a Europe-wide network, unprecedented in its density and traffic, of artists for whom the pictorial innovations of Paris (particularly, Fauvism and Cubism) were a model and an aspiration, and whose own interpretations of these contributed further to their significance and multiplicity of meanings.

In consequence, avant-gardists could lay claim to an *alternative* professionalism, whose status and standards were as carefully guarded as those of the bourgeois professionals, but on radically different terms. By 'alternative' I mean something parallel to, but less institutionally and bureaucratically legitimized than, the bourgeois variant. For we should note that the terms 'professional' and 'professionalism' have wider connotations than those that would restrict them to the bourgeoisie: the contemporary American sociologist Eliot Freidson, for example, has suggested that 'profession' should be seen as a 'folk' concept: often, he says, people make or accomplish professions by their activities, with consequences for the way in which they see themselves and perform their work, and a number of competing 'folk' concepts of profession can coexist. Other sociologists have noted that even in activities that are generally disapproved of by members of the larger society, individuals establish patterns of activity that are indicative of rudimentary professionalization, and argue that there is a real difference, for example, between a professional thief and an amateur thief, and that these differences are recognized by both professionals and amateurs in the world of crime. The American criminologist of the inter-war years, Edwin Sutherland, in the 1930s itemized the criteria for according professional status to thieves, whose autonomous situation is, necessarily, as acute as that of the bourgeois professions. Thieves' techniques, Sutherland observed, are developed to a high point by education, and the education can be secured only in association with professional thieves; for thieves do not have formal educational institutions for

the training of recruits (I shall leave aside, as too cynical, the question of what, in that case, prisons are for). Moreover, Sutherland suggested, the professional thief has status—in the criminal world, the term 'thief' is regarded as honorific; he shares with his fellows (for it is an overwhelmingly male occupation) an 'esprit de corps', or collective identity, which supports him in his career; and has milieux and networks that are largely distinct from those of the legitimate professions.

I would suggest that there are evident parallels here with the field of avant-garde art production in Paris that I have described. Fundamental to the alternative professionalism of its avant-garde formation were, as I suggested in the Introduction, three features: first, the elaboration of distinctive (energetically promoted and contested) aesthetic principles that were not only different from, but often opposed to, those of the mainstream; second, the emphasis upon, and development of, equally independent technical means and craft inheritances; and third, the mutual recognition of their common aspirations that was signalled by the epithet 'avant-garde' itself. In all of these respects—its autonomy, the safeguarding of its skills and knowledge, and its esprit de corps—the avant-garde matched the circumstances of an illicit profession such as thievery. So let us look at each of them in more detail.

The proliferation of distinct aesthetic principles and positions— the 'isms' that have become a byword for 'modern art' in the popular understanding of it—was due both to factors internal to the 'field of cultural production' and to others external to it. Internally, the growth in numbers of aspirant artists increased the self-promotional value of any declaration of a new aesthetic position or technique (it is no accident that the concept and writing-genre of the 'manifesto' was born at this time and within this field), while the mushrooming of the number of 'little magazines' noted earlier added opportunity to this incentive to come up with such innovations. The same development fostered

increasing interaction between artistic, literary, theatrical, and musical avant-gardes, since those who wrote in the little magazines about the new 'isms' in all of these media were (given the shoe-string budgets available) usually the same people. Thus, new ideas in one medium often found anchorage in others; examples are the closely contemporary rejection, around 1900, of conventional poetic metre (in the work of poets as various as Stéphane Mallarmé, Rainer Maria Rilke, and William Butler Yeats), of musical tonality (a departure pioneered by Arnold Schoenberg), and classical pictorial composition (as in the Fauvism of Matisse and Derain), as unsuited to the articulation of modern experience, and the engagement with the challenge of models of expression from non-western cultures—across the board, terms such as 'primitivism' or 'rhythm' gained currency and, with it, purchase on new developments (such as the Cubism of Pablo Picasso or the Expressionism of Wassily Kandinsky). At the same time, external factors meshed with these internal ones: such as the dynamic of consumerism, which brought the interest of a new, rising middle class in the furnishing of its domestic interiors to bear on the question of decoration, forcing the consideration of what, if anything, distinguished the 'fine' from the 'decorative' arts (the Art Nouveau or Jugendstil movement was an influential agent of this). And in between such internal and such external factors was a development that stood with a foot in each category: an art market that was shifting markedly, in most countries of Europe, from state-managed or -sponsored, centralized structures to those in which private dealers and galleries increasingly held sway, and from huge annual public Salons to smaller, more focused exhibitions. This development—a function of cultural consumerism, the diversification of the art profession, and the policies of successive governments—took perhaps half a century, from the 1870s to the 1920s, but its dynamic was a key feature of the art world of this period.

The alternative professionalism was a function, also, of the particular inheritance of the avant-garde formation in any given

city. Among such inheritances were, once again, both internal and external factors. Internal ones included the particular combination of the relation between, and relative strengths of, different cultural media and their practices (literary, artistic, musical, and so on); the leading ideas around which these practices turned; and the educational framework within which the skills and knowledges of each practice were taught. In Paris, the literary and artistic fields had jockeyed for pre-eminence for centuries by around 1880, and each in its different way had engaged with the legacy of a classicism that derived from ancient Greece and Rome via the Italian Renaissance, had been adopted by the French court in the sixteenth century, and reached what most thought had been its high-water mark in the reign of Louis XIV, in the mid-seventeenth century. This legacy furnished the core rules and principles around which the styles and movements of nineteenth-century art and literature had turned, before the emergence of the avant-garde and modernism. Alongside it was another legacy, that of the *crafts*, or the trades, of fine art making and of writing, themselves possessed of traditions and specific competences stretching back generations if not centuries, and with a depth and complexity that was a function also of the position of Paris as the capital of European culture. Together, for fine artists, such legacies fostered a deep-seated, complex, primary, and ongoing concern with the question of pictorial representation—that is, what painted marks and colours on a surface could be made to 'say' not only about their subject matter, but also about the ways in which this visual 'language' itself worked. And this concern was shared by mainstream and avant-garde artists alike, although in different ways.

The twin legacy of a body of essential (classical) knowledge and of craft skills also fostered the growth of an art education system based on private 'academies', of which the Académie Julian was the most famous, and which by 1914 numbered over a dozen. Taught most often by leading academic (and, increasingly, fashionable) artists who also ran studios at the state-sponsored

École des Beaux Arts, these 'académies libres' were originally intended as a means whereby candidates for entry to that school (the necessary passport to a bourgeois art career) could prepare for its entrance examination. But as the École became increasingly burdened by the sheer number of aspirant artists (and as the work of its Academicians fell steadily behind the curve of artistic fashion), the private academies began to supplement, then to supplant, its courses—eventually, to function as the incubators of avant-garde experimentation.

The environment of the private academies—their informality, comradeship, varied and international clientele, and relative openness to new ideas—provided significant support for the emergence of that esprit de corps, or collective identity, that was underlined by the currency of the term 'avant-garde' itself, from around 1910. Such support came also, as noted, from the little magazines, and additionally from the dynamism of the 'dealer–collector–critic' network, whose interest (both financial and aesthetic) in promoting avant-garde work led to a rapid and remarkable proliferation of exhibitions of this work, not only across Europe from London to Moscow, but across the Atlantic as well, in the five years before the First World War. Not only did these overlapping networks of art schools, magazines, galleries, art societies, and collectors give wide exposure to avant-garde fine art and help to consolidate its pre-eminence within the avant-garde that, as I noted, its particular relation to the key features of modernity had given it, but in their associated and ancillary activities they consolidated also the avant-garde formations of other media: performances of new music and dance, literary festivals, and theatrical productions were all made possible by the hectic activity and traffic within them.

A prime example of this inter-disciplinarity is the phenomenal success of the Ballets Russes in the decade from 1910. Although the impresario Sergei Diaghilev's company of dancers, choreographers, decorative artists, stage designers, and musicians

was initially a product of the Secessionist network which emerged
in the 1890s, rather than that of the avant-garde—its instant
success, on its first appearance in Paris in 1909, among the
upper-crust audience of *le Tout-Paris* was a demonstration of its
strong links within this high-society milieu, whose female
members flocked to its performances wearing dresses designed by
its leading decorator, Leon Bakst—the need that the impresario
felt to innovate constantly led him to turn to the now-consolidated
counter-culture of the avant-garde as a source of new material.
'Astonish me', Diaghilev is said, famously, to have commanded a
young Jean Cocteau in 1913 when the latter sought his patronage;
the result was the 1917 ballet *Parade*, with outrageous costumes
and drop-curtain by Picasso, quirky music by Erik Satie, and
libretto by Cocteau himself; its blatant flirting with the stuff of
popular culture (the circus, newspapers, jazz) gave it instant
notoriety. The Ballet's turn to the avant-garde had been made
already, in that year 1913 itself, with the 'scandalous success' of
The Rite of Spring, with the shocking dissonance and primitivism
of its music by Stravinsky and choreography by Nijinsky. But it
was *Parade* that consolidated this turn.

Dissemination and diversification: Cubism, Futurism, Picasso, and Duchamp

If, initially, Paris provided the example and the model for such
formation-building, its very cosmopolitanism, and the significant
number of foreign artists in its avant-garde, ensured that the seeds
of its progeny were sown in a variety of cultural composts. For
there were external inheritances also in play in each of the cities
that comprised the 'nodes' of this increasingly consolidated
network. Primary among them, perhaps, were the varieties of
nationalism that the pressures of capitalist expansion and
imperialist competition engendered in the late nineteenth century,
and which threatened the stability of Europe at the start of the
twentieth. Aspiring avant-gardists were not immune to its appeal.
In fact their attachment to the network of the avant-garde and to

feverish experimentation was often in conflict with an equal attachment to national, ethnic, or local cultural traditions, and both the configuration of their groupings and the character of their avant-gardism were shaped by the ways in which this conflict was resolved in each case. In this dynamic there were common factors. One was the significance given both to Cubism (which grew in three years from 1911 to the war from a Parisian painterly style to become the *lingua franca* of the newly consolidated avant-garde) and to Futurism (which provided an influential model for avant-gardist strategy). Another was the role of Pablo Picasso and Marcel Duchamp in establishing alternative models for the 'type' of the avant-garde artist, across all cultural fields.

The success of Cubism as a cultural idiom during the first third of the twentieth century was astonishing. It had rivals as a movement, a style, and a mode of representation—'isms' abounded in this period—but none of them had its longevity: even after Cubism had ceased to be a current style as such, its influence was felt across the arts into the 1960s. It had successors—Surrealism in particular had significant international and cross disciplinary reach—but none that matched its influence on every medium of western cultural expression, from painting (in work as various as the Futurism of Umberto Boccioni and the Neo-Plasticism of Piet Mondrian) through literature (examples are Guillaume Apollinaire and Gertrude Stein), music (Igor Stravinsky and Arnold Schoenberg), film (Sergei Eisenstein), and photography (Alvin Langdon Coburn, Antonio Bragaglia) to architecture (Le Corbusier, Gerrit Rietveld) and design (Theo van Doesburg)—its range was enormous.

It was complemented by Futurism, which had no 'signature style' but which provided an iconoclastic energy across a wide cultural front that drew on the avant-gardist aspirations of artists in all fields at the turn of the new century, and brought to them an enthusiasm for the experiences of modernity, an embrace of popular culture and skill in deploying the promotional techniques

of the new advertising industry. It was launched in 1909 by an Italian poet, Filippo Tommaso Marinetti, with a manifesto—to which I shall return—that was the first of many fired off in the five years before the First World War by the cohort of painters, writers, musicians, film-makers, playwrights, dancers, and designers whom he marshalled with incomparable flair and showmanship. Futurism caught the imagination both of artists across the nascent network of the avant-garde and of the public in all the big cities of Europe. In no time at all, it became a pan-European phenomenon, and the adjective 'Futurist' a synonym for outrageous art in all media—indeed, in all areas of social life, capturing the zeitgeist of the new century. Futurism was for the pre-1914 moment a buzzword whose ubiquity has been rivalled since, perhaps, only by postmodernism: as lacking in precise meaning as the latter, but—as such—as applicable to a wide and disparate range of cultural enthusiasms and their products. In Futurism's case all that held these together was an embrace of the shared experiences of urban modernity (for which the term 'modernolatry' was created, to match the idolatry whose 'primitivism' was the other side of the modernist coinage of that moment). And like postmodernism, but unlike Cubism, Futurism's moment of high renown was brief; ended by the catastrophic outcome of that war that it had (outrageously) welcomed, in a manifesto penned by Marinetti in 1915, as 'the world's only hygiene'.

If Cubism provided the style and, more broadly, the cultural idiom, Futurism furnished the momentum and the strategies for adventurous art, in all fields, in the new century. As such they complemented each other, together acting as the vehicle for the spread, and diversification, of the formation of the avant-garde. Their instant notoriety attracted artistic adherents and sympathetic writer-critics in equal measure, each of who acted in ways that underwrote its emergent structures: exhibitions, magazines, artist groupings were established across Europe before the First World War. But the ideology of avant-gardism, the motor which drove this vehicle, was shaped crucially for the twentieth

century by the figure of 'the avant-garde artist' that this moment produced. It was a composite figure, of which the primary component was contributed by Pablo Picasso. His precocious graphic virtuosity, his determination to avoid the easy solutions this afforded him in preference for the expressive rewards of re-inventing a pictorial language from scratch, his personal charisma and sexuality, inventive and mischievous wit, and avant-gardist ambition—the combination of these qualities pre-ordained him as the very type of artist-genius for the new century, and he occupied that role for much of the rest of it. But the century was not very old before it had produced another type, one that would come to usurp Picasso's position before it was over. Marcel Duchamp was predisposed to approach the phenomenon of avant-gardism in the Picasso mould with a certain detachment. With a comparable, if different, precocious talent, an artist for a grandfather, and his elder brothers preparing the way for him, Duchamp had a sure foundation for his artistic identity. Yet he had also acquired an artistic education that opened an oblique perspective on that identity and the accompanying avant-garde status: after a desultory five months at the Académie Julian in 1904–5 he had spent the next five as an apprentice engraver, passing a trade exam at the end of this time, and then a further five years drawing cartoons for humorous magazines. The particular combination of middle-class security, artisanal training, and popular art practice—at a moment when, as I noted, the handicraft basis of art was being challenged both by the technologies of mechanical image-making, and by the blurring of the distinction between fine and decorative art—fostered an attitude towards art-making in which an intellectual turn of mind and technical curiosity went together with scepticism towards the culture of the studio. It was one that, as we shall see, would be of seminal importance for the later history of the cultural avant-garde.

Chapter 2
Professionalisms and politics between the wars

From one generation to another

Cubism in 1914 had many possible futures, such was the range of dialects that the *lingua franca* of its style encompassed across the network of the European avant-garde. But the possibilities rested on a paradox. For Cubism was, crucially, concerned with the question of representation: the product, whether in the gallery Cubism of Picasso and Braque or the Salon pictures of Léger, Metzinger, and others, of that 'twin legacy' of classicism and the craft of painting that I discussed earlier. And Cubism was by some distance the most influential style of modernist art of that time. Yet its legacy to modernism almost everywhere except in Paris was *abstraction*, which from 1913 on imposed itself as the new language of twentieth-century art. Thus whereas with very few exceptions—Fernand Léger, Robert and Sonia Delaunay, Francis Picabia—no Cubist painter in Paris explored abstraction, all kinds of foreign artists who apprenticed themselves to Cubism or who appropriated or adapted it, whether in Paris or from a distance, did so, as early as 1914 or thereabouts: Kazimir Malevich, Vladimir Tatlin, Liubov Popova, and Olga Rozanova in Russia, Piet Mondrian and Theo van Doesburg in the Netherlands, Wyndham Lewis and the Vorticists in London, the Italian

Futurists Giacomo Balla and Gino Severini, the Americans Stanton Macdonald-Wright and Morgan Russell, to name only some. What this paradox suggests is that by 1914 the influence of the Cubist 'empire', and with it Parisian domination of the avant-garde network, had peaked and was being challenged. Also that this network had 'come of age', as it were, and its constituent nodes, cities, and groupings were acquiring independence from it, establishing other interrelationships. Indeed, to pursue the familial metaphor, the First World War marked (and largely caused) a transition, in the process of the consolidation of the avant-garde formation, from one generation to another. This chapter will trace its trajectory in the inter-war period, a span of barely twenty years that, as we shall see, not only established its pre-eminence for the history of modernist culture but also gave rise to mythic interpretations that continue to shape present understanding of it.

A second paradox, which is perhaps stranger, and for us more significant, than the first: after that period of five years before August 1914 when the epithet 'avant-garde' gained wide currency, and the qualities of formal and expressive innovation, heady experimentation, and promotional hyperbole that it connoted in the contemporary arts were everywhere remarked upon, the term seems to have almost vanished from public use—whether in the artists' manifestos, or critical essays by their supporters and detractors—for the whole of those twenty years. With very few exceptions it appears to have ceased to be a part of the vocabulary of the very network that it had until then (and has since then) denoted; and this, at the moment of what we could say was the very acme of its significance, the high-water mark of its history.

This paradox, too, points to a shift from one generation of avant-gardists to another. By 1914, the pan-European network of the avant-garde had been consolidated by the combined efforts both of increasing numbers of self-styled avant-garde artists in all media, laying claim to membership of that Paris-centred 'alternative

profession' that I described in the last chapter, and of the dealers, curators, publishers, critics, and collectors who supported, articulated, contested the meanings of, and circulated, their work and ideas. The epithet 'avant-garde' gained currency as, for some, a badge of membership, a declaration of commitment and of identity, for others a pejorative that registered their antipathy to self-promotional market strategies that had more in common with the new trade of advertising than with the artistic professions. Yet this collective effort was an ad hoc affair, unsystematic and relatively uncoordinated, and without—for the most part—a guiding sense of purpose or of what it was that was being built. Individuals acted in what they saw as their own interests, to articulate and promote their aesthetic innovations, to raise their market profile or consolidate their reputations within this new environment built on an 'alternative professionalism', to make money from the sale of new art or to invest in this art for future financial gain; and the result was the network of the avant-garde.

Thus, to take two examples: in the first years of the twentieth century, the art dealer Daniel-Henry Kahnweiler was working hard in Paris to try to sell the difficult Cubist paintings by the rising stars of his stable of artists, the painters Picasso and Braque. Cultivating a small circle of collectors, mostly from outside France, notifying them of the arrival in his gallery of new works by the pair, fostering competition between them for the acquisition of these, he encouraged some of them to act as dealers themselves in their own countries, to show their acquisitions to local artists, and to write about them in local art reviews. Circulating glossy photographs of the works to all and sundry, and lending readily to exhibitions outside Paris while requiring his artists to remain aloof from those in Paris itself, Kahnweiler nurtured the elite reputation of this 'gallery' Cubism and did much to establish Picasso as the leading artist in Europe. The consequence of these activities was to contribute to the establishment and consolidation of a market-based network of self-styled avant-garde artists and their supporters. And that

network, in sum, was the aggregation of similar, simultaneous, independent activities of other artists, dealers, collectors, and critics in cities across Europe.

At the same time, but more noisily, a young Italian poet, Filippo Tommaso Marinetti, dissatisfied with the cultural backwardness of his country, living as it was off the reputation of its glorious past, and fired by the rapid urban developments of its big northern cities, was seizing the momentum of this avant-gardism to found, single-handedly, a new movement that was to be hugely influential across most of the arts and all of the avant-garde network. Futurism, launched (as I noted in the last chapter) in a manifesto written by Marinetti and published on the front page, no less, of the leading Parisian daily *Le Figaro* on 20 February 1909, was the most radical expression to that date of avant-gardism, a declaration of war on the cultural establishment, as cultural historian Günter Berghaus has described it, intended to stimulate a renewal in the arts and in society as a whole. It burst on to the European cultural stage at a moment when new techniques and media of advertising (posters, newspapers, magazines, and film) were flourishing, and when new city-dwellers were flocking to new venues of commercialized popular entertainment (the cinema in particular joining the music-hall and the cabaret). And Marinetti, cosmopolitan (born in Alexandria, educated in Paris) and flamboyant, energetic and ambitious, recognized the potential of bringing together the experimentalism of the emergent avant-garde and the iconoclasm of that commercialized entertainment. He saw himself as both a new 'taste professional' (as another historian, Walter Adamson, has termed it) specializing in mass-cultural entrepreneurship, and as the leader of a cohort of resistance to the bourgeoisie and its stuffy culture—and over the five years before the war succeeded in orchestrating a cultural 'ism' that reached across all of the arts, disseminating by means of a hectic series of manifestos (on painting, poetry, theatre, dance, music, to name but a few topics addressed), exhibitions, and music-hall-style performances an aesthetic of an unbridled

celebration of modernity that used provocation as its principal weapon.

Both Kahnweiler and Marinetti were acting in their own interests as they saw them, recognizing opportunities that the ferment of the times presented for the entrepreneurial promotion of these interests, exploiting such opportunities independently and unprogrammatically, each with innovations in their own field. But these had the effect of consolidating and elaborating that vehicle for the internationalization of cultural experimentation, whose motor was an avant-gardism fuelled by promotional hyperbole and lubricated by an enthusiasm for artistic innovation that can be seen as one dimension of the 'rage for novelty' of that headily optimistic decade.

The outbreak of war brought most of this hectic activity to a close. Its participants went to war and were killed or kept too busy to make, sell, or collect art. Their reviews folded, their means of travel and even of any communication were destroyed or severely curtailed, the chance to show or see or hear new art of any kind was drastically reduced even in cities distant from the battlefields. But the formula for this formation survived, and enough activity continued to keep some sort of network in existence: on the 'home front' in Paris especially but also other cities, artists who were disqualified from call-up or citizens of non-combatant nations (such as the Spaniards Picasso and Gris) continued to make art, and dealers to exhibit it. Even those stuck in the trenches, such as Léger, mired in the mud of Verdun, were sometimes able to find time to paint a canvas and ship it to their home city for exhibition. Eventually the tide of war turned; with the entry of the USA into the fight an end was in sight, and both members of the pre-war formation, and a new generation of younger artists and their critic supporters, picked up the traces of the network. The difference between this moment and that of the pre-war, however, was that both this network (or what remained of it) and the avant-gardism that drove its exchanges were now

givens—that is to say, the former a professional frame of reference, and the latter a disposition or attitude, that were already sufficiently normalized to provide, between them, an existing working environment within which initiatives could be taken and positions occupied. For the younger generation—artists (in the widest sense of the term) who came of age in the immediate post-war years—the collective identity as an 'alternative' profession was therefore no longer something to be asserted but assumed, and the somewhat hyperbolic rhetoric in which avant-garde status was formerly declared was no longer necessary; hence the falling of the term into disuse. We could say (and I shall return to this) that the avant-garde was on the way to becoming an institution.

Shaping the inter-war avant-garde

But if the *existence* of the formation and the network could be taken as given, as the normal environment for entrants into this alternative profession, the *character* of it could not; nor was it as homogeneous as before 1914. The pre-war avant-garde was founded, as I have noted, on aesthetic positions and inheritances which, for all their rivalries, shared a commitment to technical and formal experimentation that took three things for granted: first, the value of cultural practices and innovation within them; second, the centrality of individualism for creativity; and third, the relative autonomy, or independence, of both practices and innovations from wider social forces. It was the alternative and oppositional character of their arts (whether painting, sculpture, writing, music, theatre, photography or film) that distinguished their professionalism from the mainstream, liberal bourgeois, variant. The avant-garde that re-emerged after the war, however, was shaped by the profound political, social, and economic changes which that catastrophe had caused; as a result it was at once more internally divided between alternative, indeed opposed, positions, and more profoundly radicalized, both politically and professionally.

We can describe these changes, a little schematically, as comprising three factors: social dynamics which, between them, created the social and cultural pressures and tensions that shaped this avant-garde. The first was a universal rejection of the values and policies that had led to the war, and a commitment to their replacement with better ones. What these were, of course, depended on where one stood. For some it entailed a return to tradition and order that were at once social, political, and cultural (in France the term 'the call to order' was a rallying cry, particularly for the more conservative, including those within the avant-garde formation); for others a rejection of the narrow profit-maximizing values of capitalism and bourgeois materialism (the Dada movement was the noisiest in declaring this position).

The second factor was the dynamic force of national, international, and monopoly capitalisms. This too had more than one aspect, which we could summarize as external and internal. As I noted earlier, the leading corporations of the victorious nations took advantage of the system of inter-government controls on wartime economies, and of the dismemberment and dispersal of the German pre-war economic empire, to establish their external profiles and to consolidate their international reach and relationships. Internally, they put in place practices of machine production, assembly lines, and the close regulation of workers' activities, following Frederick Taylor's influential 1911 treatise *The Principles of Scientific Management*. Similarly, on the external model, cultural avant-gardists developed the informalities and rudimentary procedures of the pre-1914 network into a more formal set of protocols, setting up (on a considerably smaller scale than the corporations) the equivalent paraphernalia of cultural exchange: international conferences and congresses, magazines aimed at an international readership, ambitious manifestos and survey exhibitions, on all aspects of art, design, architecture, and, increasingly, photography and film. Equally important was the internal model: the development of the role of design in industrial

production, as artists and entrepreneurs in several countries, encouraged by their governments, sought to build upon the example of the pre-war, pioneering German Werkbund in adapting the innovations of the artistic avant-garde to the requirements of consumer-goods production, and the espousal of the efficiency and rationality of machine production as a guiding aesthetic principle. Thus the regulating of workplace activities found cultural expression in a turn to address 'use' in art, as maintaining the effective or efficient performance of social roles. Many began to imagine this industrial logic in machine-metaphors, against accounts of culture as without use. Architect Le Corbusier would famously rethink the architecture of the home as a 'machine for living'.

The third factor was the opposite of the second: the upheaval of the Russian revolution in late 1917, the impact of this on neighbouring states, and the example it set for their discontents. Avant-garde artists, already predisposed, as marginalized and oppositional cultural workers, to welcome revolutionary change as promising a revaluation of their creativity, for the most part supported the Bolsheviks, and in cities not only in Russia itself but also in the defeated countries where revolutionary forces briefly held sway—such as Berlin and Budapest—most rushed to lend their professional skills to its cause.

Common to all three factors was a rejection of individualism in favour of collectivism, whether this be that of an assault on the status and value of aesthetic experimentation for its own sake, a commitment to putting such experimentation in the service of social and economic utility, or a marshalling of the collective political power of the organized working class; and in many cases the vehicle for these values was a sense of professionalism. But at the same time, they stood also in sharp opposition to each other in political, cultural, and social terms: those of capitalism against Communism, classic against romantic, elitism against democracy. We need to explore the character of these commonalities and

differences, and their consequences for the 'alternative professionalism' of the avant-garde.

The avant-garde and the 'call to order'

The rejection of the values that had led to the war took several forms, and the professionalism to which many were attached was defined in different ways. One of these was in terms of 'efficiency'. From the middle years of the war there developed in France an enthusiasm for collectivism, and a rejection of individualism, as the condition for both military victory and post-war rebuilding. As art historian Kenneth Silver noted, this enthusiasm ran the gamut of cultural practices from cuisine to architecture. Thus, in the name of efficiency the individual flair and creativity that had been the hallmark of French cuisine were displaced, in the hand-wringing debates between cultural commentators that filled the newspapers, by the values of scientific calculation of calorific values, and a 'Scientific Society for Nutritional Science and the Rational Nourishment of Man' was founded in 1916 to promote this. A year later a comparable attempt was made to establish a French national regime of fashion, with the launch of a 'National Shoe' that everyone might wear in the cause of wartime economy!

Less frivolous perhaps was the critique of Cubism that developed within the avant-garde from the same moment. On the home front, former Cubists and associated critics condemned the pre-war movement for its obsession with personality and individualism, its 'disease of one-upmanship', in the words of one of its members, painter André Lhote. His friend Maurice Denis, also a painter as well as an influential voice among avant-garde artists, declared that 'the excesses of individualism...the fetishism of the unexpected and the original—all the blemishes on our art are also the blemishes on French society'. At the battlefield itself, Fernand Léger enthusiastically swapped his former concern with abstract experimentation for a sense of camaraderie with his

fellow soldiers—'there I discovered the French nation', he later wrote—and the beauty of military machinery.

Less than a week after the war ended, in mid-November 1918, a manifesto entitled *Après le cubisme* (*After Cubism*) was published which theorized this collectivist, machine aesthetic in terms that linked it with the professionalism of the technician, the scientist, and the engineer. Its authors, the painter Amédée Ozenfant and the architect/painter Charles-Édouard Jeanneret (who adopted the name 'Le Corbusier', with avant-gardist self-promotional *chutzpah*, a little later) celebrated the 'modern spirit' which lay in the stylelessness of industrial machinery, engineering projects such as bridges and dams, functional buildings such as grain silos—in which they also saw a link with the classical past, through their values of monumentality and precision that gave them a Roman grandeur and a classical order. The manifesto, published to promote their exhibition of what the two men called their 'Purist' paintings at a Paris gallery (Figure 2), condemned art that simply ran wild under the banner of imagination or originality (those very values, it will be remembered, celebrated by Shelley in his 'Defence of Poetry' exactly a century earlier), and declared instead the importance of technical mastery, the meticulous application of scientifically based and mathematically derived rules of composition; and it advocated that artists see themselves as technicians of visual communication, alongside the graphic designers who worked in the advertising industry. In the magazine that he co-edited from 1920 to 1925, *L'Esprit nouveau* (*The New Spirit*), Le Corbusier would later develop this advocacy into a call for a professional collaboration among scientific, artistic, and industrial elites—an echo of that Saint-Simonian avant-gardism we encountered earlier.

This espousal of an aesthetic of order, as both modern and classical, and as an antidote to the chaos of experimentalism that had preceded (and for some, caused) the war, was shared by avant-gardists across the arts, particularly in France where, in

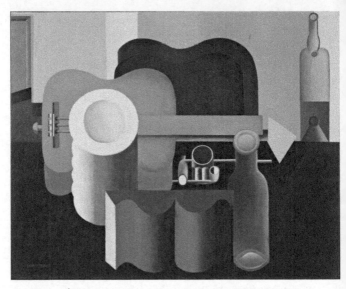

2. Charles-Édouard Jeanneret (Le Corbusier), *Still Life*, 1920

times of social crisis, classicism had long been a refuge for those seeking to re-assert a national identity. In literature André Gide and Paul Valéry led what the critic Jacques Rivière perceived as a 'classical renaissance'; in music, it was represented by Erik Satie's cantata *Socrate*, which he saw as 'white and pure, like the Antique', and Stravinsky's 1920 ballet *Pulcinella*, which combined *commedia dell'arte* themes and neo-classical harmonies. The instigator of this ballet was Diaghilev, who was instrumental in promoting what dance historian Lynn Garafola has called 'period modernism', but also active in encouraging this return to tradition was the sewing machine heiress and leading member of Parisian high society, the Princesse de Polignac, née Winaretta Singer.

Thus many inside and outside the avant-garde, particularly in Paris, and not least those with a stake in the social status quo, were fashioning a sense of order that linked the values of modern

technology to those of the classical past. This was a linkage that also underlay the Fascism that took over Italian politics from the early 1920s, with its name taken from the ancient Roman *fasces*, the bundle of sticks that symbolized the collectivism of that Republic, and its obsession with industrial modernization, symbolized perhaps in its achievement in making Italian trains run on time. Indeed the links were in some cases more than coincidental, as several in the cultural avant-gardes made common cause with Fascism in those years.

Dada against the bourgeoisie

This 'call to order' that was at once aesthetic, social, and political was energetically challenged, however, by another kind of rejection of the war and all that led to it: that of the Dada 'movement' which emerged across the western world, from Romania to New York, from not long after the start of the war until the early 1920s. Although the emphases of the several Dada groups—in Bucharest, Zurich, Berlin, New York, Hanover, Cologne, Paris—differed so widely that calling it a movement stretches this term, they shared a rejection of 'bourgeois reason'— that narrow, calculating, profit-making, 'instrumental' rationality that they saw, not as holding the key to post-war economic success, but as having driven the world to war like lemmings to a cliff-edge. And to varying degrees, using a gamut of strategies from humour, through provocation, the use of chance, to political activism and revolutionism, they sought to undermine, or ridicule, or destroy the regime of that reason. Thus in Zurich (the city where, at the same time, exiles James Joyce and Lenin were, respectively, writing *Ulysses* and planning the Bolshevik revolution), at the Cabaret Voltaire through 1916 Hugo Ball, Emmy Hennings, and Tristan Tzara were performing nonsense plays and insulting their audiences with absurdist, scatological poems, and at the Galerie Dada through 1917 Jean Arp and Sophie Taeuber were showing art made 'according to the laws of chance'. At the centre of these activities was not only the aim of

provocation but also a profoundly serious aesthetic purpose: to dismantle the devices of artistic (in the broadest sense) meaning and explore their components—words, gestures, images, sounds— and then to re-make meanings anew, from these building-blocks, as a means of starting afresh without the trappings of 'bourgeois' cultural forms. What brought them together in this aim was a belief, inherited from the avant-gardism of the pre-war generation, in their role as professional specialists in this kind of work—alternative professionals, to be sure, in their opposition and hostility to the liberal-bourgeois variant, but nonetheless not far removed from Le Corbusier's concept of artistic professionalism.

Elsewhere, across a subcultural and professional avant-garde network that was rapidly re-connecting the traces of the old, similar activities were being undertaken, in different emotional registers. In Berlin, where the consequences of the war were immediate, profound, and inescapable, the Dada movement that emerged at the close of 1918 (a Dada Club was founded then by Raoul Hausmann, Richard Huelsenbeck, and Johannes Baader) was correspondingly politically and socially engaged: the 'First German Dada Manifesto' that they published at that time declared that 'the highest art will be that which in its conscious content presents the thousandfold problems of the day, the art which has been visibly shattered by the explosions of last week...The best and most extraordinary artists will be those who every hour snatch the tatters of their bodies out of the frenzied cataract of life, who, with bleeding hands and hearts, hold fast to the intelligence of their time.' The Berlin movement, which also included George Grosz and Hannah Höch, was involved in the social upheavals and the Spartacist revolution which broke out at the end of the war in the German capital. Its art images and objects, ferociously subversive, made striking use of the medium of photomontage. (Figure 3).

In New York, by contrast, which was most distant of all participant cities from the battlefields, untouched by the

3. Hannah Höch, *Cut with the Kitchen Knife Dada through the Last Weimar Beer-Belly Cultural Epoch of Germany*, 1919

destruction, whence Paris-based artists Duchamp and Picabia had fled the conflict, they mounted a demolition of the status of art and the artist in bourgeois society. Duchamp, famously, submitted a urinal as a sculpture in a New York exhibition (it was rejected), as the first of a series of what he called 'readymades': ordinary objects proposed as works of art simply because he, an artist, had

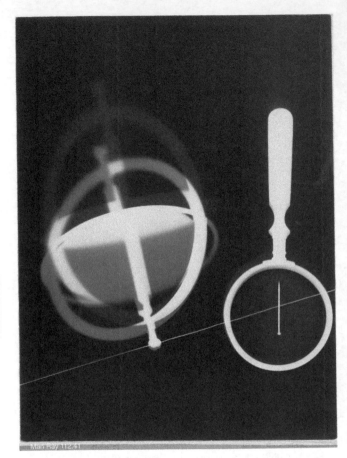

4. Man Ray, *Rayograph*, 1922

decided that they were (he often subverted their use in so
proposing them; *Trap*, for example, was a coat-hook rack nailed to
the floor as a dangerous obstacle for the unobservant gallery-goer).
Picabia made blueprint-like drawings and paintings of machinery
that suggested sexual double entendres: a spark-plug entitled

Young American Girl in a State of Nudity, for example, or the drive-wheel and piston of a motor entitled *Girl Born Without a Mother*, sending up modern fetishization of machines. These exiles were joined by American artists, most notoriously, perhaps, Man Ray (born Emmanuel Radnitzky) from Philadelphia, whose pioneering experiments with cameraless photography produced haunting images (Figure 4), like the shadows of the objects or figures that had created them, seemingly without the intervention of a creator, subverting the status of the artist less provocatively than Duchamp or Picabia, but perhaps more poetically.

Constructivism and the machine

In their poetry of (often mass-produced) things, as well as in their manipulations of the mechanized image, these 'Rayographs', as Man Ray inevitably called them, overlapped with a set of concerns that in other ways stood at some remove from such imagination-driven provocations of Dada. At the same time as the Rayographs, Hungarian artist Laszlo Moholy-Nagy was making what *he* called 'Photograms' (Figure 5). Similarly made by directly exposing to light things placed on or against light-sensitive photographic paper, Moholy's closely comparable images grew out of a commitment not to the poetry of things or the debunking of artistic creativity but to the promise that the machine, modern technology, and rational constructive principles held out for the post-war world. His was an avant-gardism that was shared by a large cohort of young artists in the decade after 1918 across Europe, whose excitement at the potential of scientific method and modern engineering brought them together in what became known as the Constructivist movement. In the words of one historian of this cohort, Gladys Fabre, they 'made the machine their hobby-horse, vaunting its functionalism, its qualities of speed and precision, and its capacity to destroy traditional art'. This had close parallels with the machine aesthetic of Le Corbusier and Ozenfant's Purism, but in place of their attachment to classical values (and through them also, implicitly, to a

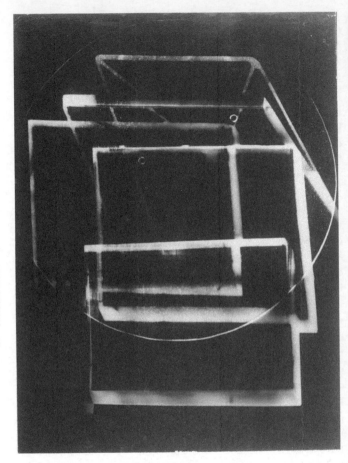

5. Laszlo Moholy-Nagy, *Photogram*, 1924

hierarchical social and political order), Constructivism looked for
inspiration elsewhere: both to the *dynamism* of modern industry,
and (as we shall see) to the example of the Russian avant-garde of
the immediately pre- and post-Revolutionary years—both its
aesthetics and its politics.

Fundamental to their technologism, though, was a commitment to collectivism that, again like Corbusier's, was expressed partly in (an alternative) professionalism. This had several aspects. It was an attachment to the idea of the avant-garde artist as a skilled specialist in visual communication that had led to that paradox I noted at the outset of this chapter: that the painterly tools provided by Cubism's interrogation of art's means of representing the world encouraged many of those who had learned to use those tools to cross, all at once in 1913–14, the threshold into *non*-representational, or abstract, painting. For those who took this step, the craft-cum-classical inheritances of Parisian art were less important than the role, which their new avant-gardist identity gave them, of 'pushing the envelope' of their specialism. To this motivation, in the post-First World War moment, were joined the promise of collective endeavour, the model of scientific method, and the awareness of the role of both in the operations of modern industrial corporations.

The collectivism led, even before the war was over, to the emergence of the first of a new generation of 'little magazines' that became a primary medium for avant-garde networking. In neutral Holland, in 1917 a group of young artists including Theo van Doesburg and Piet Mondrian, and the architect J. J. P. Oud, founded the magazine *De Stijl* with the aim of promoting a new peacetime consciousness in which national animosities would be replaced by universal values. True to this, in the month that the war ended (and simultaneously with *After Cubism*) *De Stijl* published a manifesto in four languages exhorting progressive artists all over the world to 'work for the formation of an international unity in Life, Art and Culture'. *De Stijl* had been preceded by *MA* in Budapest (founded in 1916), and was soon followed by other magazines—*L'Esprit nouveau* (as we saw) in Paris in 1920, *Zenit* in Zagreb in 1921, in 1922 *Stava* in Prague, *Veshch* in Berlin, *G* the next year in the same city, and *Merz* in Hanover—to name but a few. Of course, such magazines produced by artists (as well as by writers) in the avant-garde formation were

not new; as I noted earlier, over 200 of them were founded, and many folded, in the fourteen years before the First World War in Paris alone, as artists without dealers, and poets without publishers, realized the benefits of such a means of promotion of their aesthetic innovations. But the post-First World War generation added, to this awareness, two others: first, that the already-existing international network to which they belonged was a public forum in which they needed to present their ideas, and look for opportunities for debate, even controversy, in order to establish them; second, that such magazines were almost the only possible channel of communication for this purpose. In other words, the magazines did not so much carve open a cultural space for themselves (as the pre-war ones had done) as occupy a space that was still open—as an appropriately modern, collective, form of expression and communication.

The appearance of these magazines differed accordingly, at least once their collective status had been recognized by the early 1920s. Where their pre-war precursors (and their own first issues) looked 'literary' and fairly conventional in layout, the new titles almost all declared their allegiance to the values of modern technology, rationality, and industrial collectivity in the very design of their covers, where geometric compositions, innovative sans-serif typefaces, machine imagery, and sometimes photomontage increasingly predominated. The connotations were all of precision, efficiency, and functionality. A similar rhetoric, and similar attachments, coloured the promotion of the art exhibitions and artistic gatherings that proliferated during this period, mimicking in its vocabulary the bureaucratic impersonality of economic and political organizations: thus the First International Dada Fair, held in Berlin in the summer of 1920, was an anti-exhibition in the guise of a trade show; a Congress of International Progressive Artists (held in Düsseldorf in May 1922) was followed by a Congress of Constructivists and Dadaists in Weimar that September; quickly it became obligatory for any exhibition worth noticing to have 'International' in its title.

As Czech artist and theorist Karel Teige declared, 'the old type of exhibition is all but extinct, resembling too much a gallery-mausoleum. The modern exhibition must be a bazaar (a fair, a world expo) of modern production, a manifestation of the electric century of the machine.'

For some artists within the Constructivist movement, expression of their attachment to the values of modern technology and industrial efficiency went beyond rhetoric into design activities. With the creation of the Bauhaus in Weimar in 1919 on the initiative of architect Walter Gropius, and more especially with its shift in the early 1920s from an aesthetic grounded in handicraft and individual expression to that symbolized by machines and machine production, their employment as teachers, or their experience as students, turned some artists into designers: such as Marcel Breuer whose tubular steel chairs have become design classics. Others, such as Moholy-Nagy, extended their activities from painting to include sculpture, photography, and film as well as teaching and theoretical writing. Still others sought to extend not just their practice, but the application of Constructivist principles, across as many arts as possible in the creation of a universal, inter-disciplinary language for the arts.

Exemplary in this ambition was the Dutch artist Theo van Doesburg, who was also in key ways the very type of the professional avant-gardist of this generation. Born in 1883 and beginning his career as a painter (he had his first solo exhibition in the Hague in 1908), van Doesburg also worked in stained glass, typography, architecture, poetry, and art criticism in a short, intense life that ended in 1931. Perhaps more important even than this multi-disciplinary range, though, were his abilities as a networker and activist on behalf of the entire avant-garde. A born organizer and, by all accounts, a driven man, he worked constantly from the end of the war to make his mark across Europe and to expand his network and influence, and his combination of progressive artist, organizer, editor, and motivator was highly

effective in marshalling others behind his plans and magazines. Yet van Doesburg was as combative as he was catalytic, always on the lookout for controversy and competition, even at the cost, where he judged it necessary, of the abandonment of his previous aesthetic principles. Thus at the same time as working to promote the machine-centred rationalism of Constructivism, he adopted—unbeknownst to most of his Constructivist colleagues—the pseudonym of I. K. Bonset, under which he wrote and published poetry in a Dada spirit that mocked Constructivism's very principles! And in 1921 he moved to Weimar where the Bauhaus had opened two years earlier (making it his base there for two years), immediately starting a rival design course to that of the latter which drew increasing numbers of its students, thereby creating huge disquiet within the Bauhaus faculty. This contributed greatly to the fundamental shift which Bauhaus teaching underwent, from hand-crafting to the teaching of technology and design for machine production.

Van Doesburg was perhaps unusual in this desire to become the driving force of the pan-European avant-garde, the CEO of 'Avant-Garde Inc', but his energetic, contradictory and short career does illuminate two important features of the formation, as it developed over his post-war lifetime. One is the coexistence of both similarities and differences between proliferating 'nodal' cities and groups within the network that it rapidly became in the post-1918 decade (replacing the pre-1914 'wheel-like' structure, of a Parisian central hub connected, as with spokes, to peripheral, mutually independent groups on its rim). Thus the shared commitment to internationalism existed in tension with a range of localisms and specific cultural inheritances that separated their 'isms' and their ambitions; thus, too, the shared determination never to return to the values that had led to the catastrophe encompassed, as I have shown, the opposed attachments to order and disorder.

The second feature is that an embrace of the values of corporate collectivism and machine technologies could comprehend both an

acceptance of capitalism and a commitment to its revolutionary overthrow. (In this context it is worth recalling Lenin's well-known enthusiasm for Taylor's proposals for the 'scientific management' of capitalism.) This last point is worth emphasizing, for—as we shall see in Chapter 4—the differences in political engagement that can be found within this generation of the avant-garde call into question the assumption, now dominant if not universal, that the aesthetic radicalism that distinguished the avant-garde went necessarily with left-political radicalism. For some of its constituent groups, however, the two radicalisms did indeed go hand in hand, and the model that this relationship established was to be of fundamental significance for the future, both of the concept and of the formation.

The proximity of revolution

If, as I have argued, it was an 'alternative professionalism' that distinguished the formation of the avant-garde from mainstream culture, it was still a *kind* of professionalism—that is, a collectivization of the identition and practices of art-making (in its widest sense) according to agreed criteria of competence and inheritance that protected the interests of its members. As such it was, arguably, a vehicle for the *institutionalization* of this cultural network; a process that, equally arguably, had the effect of sidelining the idealism that characterized the original concept of 'art as avant-garde', in both Saint-Simon and Shelley—of prioritizing one side of the tensions or contradictions that, as we have seen, the concept contained, at the expense of the other. In this perspective, the third of those factors shaping the post-First World War avant-garde that I outlined earlier—that of the proximity of the Bolshevik revolution in Russia—becomes doubly significant, for just as that revolution posed the biggest-ever challenge to a capitalism that was by now in its pomp, its implications for the cultural avant-garde and its avant-gardism were the most extreme, presenting what we could call the 'limit case' of the *other* side of those tensions or contradictions. For the

Russian revolution gave artists the chance to play the role that Shelley had claimed for them, of being 'the unacknowledged legislators of the world', and shaping the new, post-revolutionary society by the force of their imagination. And as we shall see, it enabled the recuperation of Shelley's idealism for a more general (and extremely influential) understanding of what 'avant-gardism' meant, and of what the avant-garde 'essentially' was.

There was a lively contingent of the pan-European artistic avant-garde network in Russia by the time the outbreak of war in August 1914 plunged that country into an isolation that lasted beyond 1918. The artists (of all kinds) who were part of it were schooled as much in political upheaval, since the failed revolution of 1905 and the political instability that followed it, as in aesthetic experimentation, and when the Bolshevik revolution came they welcomed it. Some were ready to exchange their aesthetic interrogation of the languages of cultural expression (whether these be literary, musical, or visual) for the making of useful art: in place of baubles for the bourgeoisie, they sought to make things that either were practical or furthered the revolution in some way. Thus Aleksandr Rodchenko and Varvara Stepanova swapped painting and sculpture for designing posters and boiler-suits; the poet Vladimir Mayakovsky made propaganda posters with inspirational slogans; Liubov Popova turned to the design of cheap-and-cheerful dresses and stage sets for plays by the theatre director Vsevolod Meyerhold that carried the message of the revolution; most notoriously, Vladimir Tatlin designed a 'Monument to the Third [Communist] International' (Figure 6) that was intended both as functional architecture (combining different spaces for the several levels of government, rotating on their axes at different speeds) and as symbolic of the dynamism of soviet society: it was to be half as high again as the Empire State Building would be in New York, would project the news onto the clouds with searchlights, and broadcast to the world from its radio beacon—all this in a country ravaged by civil war and with the armies of nearly two dozen hostile nations on Russian soil!

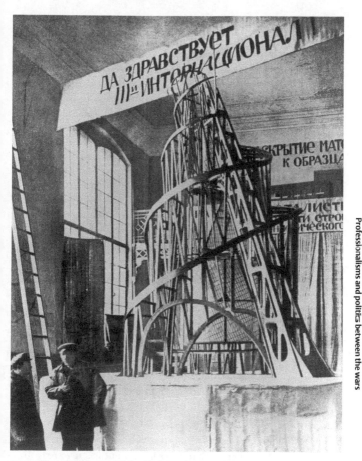

6. Vladimir Tatlin, *Model for the Monument to the III International*, 1920

The utopianism of these avant-gardists has long been emphasized, as has their apparent vagueness as to just *how* art might further the revolution, yet the ideas that seethed in the circles of these self-styled 'Productivist' artists had a force of attraction that proved magnetic to others within the avant-garde network outside Russia, especially those in countries adjacent to it, or that were

experiencing revolutionary upheaval of their own after November 1918. The ferment of these ideas about the relation of artistic and political revolution can be seen in the 'little magazines' they wrote and published: the Hungarian *MA*, the Serbian *Zenit*, the Polish *Blok and Dzwignia* all had strong left-wing, radical, and anti-establishment attitudes. Berlin, where a revolution was attempted and failed in the winter of 1918–19, was perhaps the capital of these interlaced cultural and political avant-gardes, with members of the Expressionist movement, and of Berlin's Dada contingent, active in revolutionary political groups such as the Spartacists. The message of the Bolshevik revolution spread further over the succeeding years: if the Surrealist movement, founded in 1924 in Paris by André Breton and friends, was not caught up in revolutionary upheaval, it displayed and developed an intellectual sympathy for Bolshevism, many of its members joining the French Communist Party and elaborating a programme in which the twin aims of psychic and social revolution, and their relation, were obsessively explored.

But as the history of the Surrealist movement, from the mid-1920s to the mid-1930s, demonstrates, this relation was by no means straightforward—Freud (on whose psychoanalytical theory Breton's own ideas were built) and Marx were uneasy bedfellows. So too, more particularly, were Communism and capitalism, and not all avant-garde artists' groups chose the former: Futurism, especially that of its founder and impresario Marinetti, was closely attuned to Fascism, and Marinetti himself active in its support, in 1923 declaring that Fascism and Futurism were engaged in a common revolutionary enterprise. In London, the Vorticist group that coalesced briefly in the summer of 1914 around painter-writer Wyndham Lewis, poet Ezra Pound, and sculptor Henri Gaudier-Brzeska espoused a patriotic 'jingoism' that was at variance with the internationalism driving much of the energy of the avant-garde's circuits. And that internationalism itself was strikingly unpolitical for many of those who espoused it: as art historian Kristina Passuth noted in an essay of 2010, 'from

the standpoint of their social networks, politics hardly mattered at all... Immediately after the first world war, it was the goal of avant-garde artists to break away from their national issues and prejudices and compete with each other in a broader, international context.' Underpinning much of this internationalism was a commitment to the autonomy, or independence, of their art. It was this commitment that prompted the publication in March 1923 of a 'Proletarian Art Manifesto'. Signed by several of the leading Dada and Constructivist artists of western Europe, including van Doesburg, Tristan Tzara, Kurt Schwitters, and Arp, it declared the opposite of what its title implied: a hostility to extraneous intervention in matters of art that was fuelled by distrust of the Communist parties of Russia and elsewhere. The virulent criticism by the leftist political avant-garde of the First International Dada Fair in Berlin in 1920 stung these artists to an excoriation of the outmoded and bourgeois tastes in art of the working class. As historian Marc Dachy suggests, this manifesto (and Dada itself, in light of it) walked 'a tightrope between the reactionary hostility that led [via Nazism's condemnation of "degenerate art"] into a disastrous war, and the incomprehension of the revolutionaries'.

We shall explore in a later chapter the political implications of cultural avant-gardism, and the relation between them, but the range of attitudes surveyed briefly here indicates that the political dynamic of the Bolshevik revolution, and the impact of proximity to it, affected many but not all avant-garde artists of the post-1918 decade, and that the tensions between the ideals of Communism and the hegemony of capitalism were pulling members of its network in different directions. We could say, too—and again, I shall return to this—that the 'alternative professionalism' of this avant-garde generation, developing towards its institutionalization, was increasingly at odds with the ideals inscribed in the original concept of 'avant-garde'. The tensions of this could be summarized, provisionally, as those between the history of the formation of the avant-garde and the ideology of

avant-gardism: a tension that was, perhaps, inherent from the start of the formation itself. Before we take this further, we need to explore more fully the dynamic of that part of capitalism's twentieth-century development that was closest to the practices of the cultural avant-garde: consumerism and commercialized popular culture.

Chapter 3
Consumerism and co-option

Sometime early in 1913 Picasso made an assemblage in his Paris studio that we know only from his photographs of it taken in mid-construction, and which surely only lasted for a few days, if that (Figure 7). It is a strange work. A folding screen is covered with sheets of drawing paper, on which are the outlines of one of those severely pictographic figures that probably only he, Braque, and his little group of *aficionado* collectors could decipher, made of vertical rectangles with a skewed rectangle where its face might be. Pinned to the screen are two 'arms' made of newspaper, one roughly in the region of the right shoulder, the other nowhere near the figure; they end in cartoon hands that 'hold' a real guitar, which is in fact suspended by string from the top of the screen, in front of which (on a low table) are a bottle, a newspaper, and other less discernible objects. The assemblage is one of a number of three-dimensional constructions that Picasso made out of everyday, often scrap, materials around that time, and the schematic figure is closely related to several of his paintings and pasted-paper works of the spring of 1913. As such, it is a strange combination of the recognizable and the unreadable, of ordinary things and an arcane representational code; a dialogue between avant-garde experimentation and tokens of popular culture, unprecedented in the starkness of their juxtaposition. Why did Picasso make it, and what does it tell us about the relation of the artistic avant-garde and the commodity culture then flourishing?

About the cultural and social position of that newly consolidated avant-garde? And has this position changed, in the century since then? These are the concerns of this chapter; because, as we shall see, the attraction of commercial popular culture for progressive artists, and their ways of engaging with it, are of key significance for the character and the fate of the avant-garde as a formation, of 'avant-garde' as a concept, and of the values for which each stands.

7. Pablo Picasso, *Construction with Guitar Player*, 1913

The early twentieth century: between high and low

The burgeoning growth of consumerism that characterized western capitalism, and shaped Paris, from the mid-nineteenth century (and that continues to drive a now globalized society in the present) included the proliferation of its commercialized popular culture, for reasons—and in ways—that were both technological and socio-economic. Technologically, the new café-cabarets that lined the new boulevards, and the new music-hall entertainments, soon to be followed by cinemas, that nightly drew huge urban crowds, were lit by modern gas, and soon electric, lighting and were promoted by colour-lithographed posters and notices in new mass circulation newspapers that were themselves funded by such advertising. Socio-economically, the new populations flocking to the cities to find work found their lives shaped by the demands of production schedules and work discipline, their leisure time regimented by the factory clock, their leisure pastimes driven by the profit motives of a developing culture industry and policed (including through censorship of popular songs) by the state. All this was because capitalism has a stake in the culture of the popular classes, and the constitution of a whole new social order around its needs in a newly modern mass, urbanized society required a more or less continuous, if uncoordinated, process of re-education of its workforce to acquiescence in its highly unequal social relations; if the obtaining of its bread could be left to the people, the provision of circuses needed to be ensured. As sociologist and historian Stuart Hall notes, 'popular' culture is defined by the dynamic of the relations between dominant and subordinate social formations. This is not to say that the forms of this commercialized popular culture were simply imposed on its audiences; as the notoriously raucous and rowdy behaviour of music-hall audiences attests, its consumers took an active part in shaping them. But the forms were largely given, nevertheless (and equally largely intended to make money for their owners).

The coincidence, which you may have noted, of this rise of commercialized popular culture in the mid- to late nineteenth

century and the emergence of the formation of the cultural avant-garde was in fact no coincidence. The two were integrally related: first in that the aspirant, anti- or un-academic artists, writers, composers and musicians, playwrights and actors who came to make up that formation were part of popular culture's audience, and shared the social marginalization (not to speak of the straitened circumstances) of many others in it. They enjoyed its informality, its articulation of their own sociality, its irreverence towards pompous authority (Picasso and his friends, for example, loved going to the Medrano Circus down the hill from his Montmartre studio, and the artist himself avidly read the cartoons in the daily newspaper; the composer and pianist Erik Satie gave up concert performance for piano-playing in a bohemian cabaret). They were related, second, in that many of them were active within it, as creators of this culture. The Chat Noir (Black Cat) cabaret, for example, which opened on the slopes of Montmartre in Paris in 1881, drew substantial audiences to performances of poems, songs, and monologues organized on principles close to those of present-day 'open-mic' stand-up comedy and karaoke sessions, whereby the proprietor would solicit proposed items for performance from the crowd of diners and drinkers at the start of the session, then select and order them, thereby providing new and unknown writers, singers, and actors with a ready-made venue and audience. Like present-day 'stand-up', this was a subculture of 'fumisme' (which roughly translates as 'practical jokery') that fizzed with ribald mockery and sharp critique of established authority, and that brought together the imaginativeness of aesthetic radicalism and the irreverent vitality of 'street' culture—and that made money out of it, such that in 1885 the cabaret moved, with much fanfare including a street procession, to much bigger premises just a few blocks away, where it continued to attract full houses of an increasingly fashionable clientele.

Perhaps more importantly for our concerns, they were related, thirdly, in that the character of this culture fed directly and rapidly

into the iconoclasm of the nascent avant-garde. The humour of 'fumisme' was often absurdist, and directed at existing aesthetic as well as social conventions: exhibitions of 'fumiste' art (by a group who called themselves 'The Incoherents') included a drawing of the Venus de Milo with the head of a bald, bearded man, for instance, and a monochrome white painting entitled *First Communion of Young Girls in a Snow-Storm*; and this was a vein of humour well suited to the anti-realistic and symbolist aesthetic, and the parodic inclinations, of the literary and painterly circles that incubated the avant-garde. Thus Alfred Jarry's play *Ubu Roi* (Ubu the King)—now seen as marking the start of the theatrical avant-garde—which opened at the little symbolist Théâtre de l'Œuvre in Paris in December 1896, and so scandalized its audience that it ran only for two nights, shared much of this absurdism, as well as other features designed to provoke outrage: stage sets of deliberate crudeness, a lack of narrative, actors moving like puppets, an obsession with excrement and obscene language. A dozen or more years later Marinetti, who was deeply impressed by Jarry's play, introduced the genre of Futurist *serate* ('evenings') that took its provocations to new limits, drawing on the traditions of music-hall with its lively customs of (sometimes uproarious) audience participation. In 1913 Marinetti wrote a manifesto in praise of popular theatre: 'The Variety Theatre is alone in seeking the audience's collaboration', he declared, 'It doesn't remain static like a stupid voyeur, but joins noisily in the action, in the singing, accompanying the orchestra, communicating with the actors...[and] the action develops simultaneously on the stage, in the boxes, and in the orchestra.' Picking up from these features of popular theatre, the Futurists developed strategies and techniques of attracting huge crowds to these *serate*, of goading them through the provocativeness of their on-stage performances into noisy response, and of managing the resulting chaos as a new art form, one that made a clear break with all the conventions of mainstream theatre. In another register, it is no coincidence that many painters of the Cubist circle around 1910 made a living as cartoonists, among them

Marcel Duchamp and Juan Gris; this was aesthetically appropriate (as well as financially necessary), since (as art historian Adam Gopnik noted in a 1983 essay) a cartoon is 'a working representational code that comments on the ways representational codes work'—which is also a good description of the devices of Cubist painting.

It is important, of course, not to collapse avant-garde culture into popular culture. For the makers of the former the differences between them were crucial; because if an embrace of the everyday, disposable and vital qualities of the latter was a valuable means of distancing their 'alternative' professionalism from the status-conscious mainstream variant, and of dispensing with the empty virtuosities of that mainstream's cultural practices, there was no wish on the part of avant-gardists to demote their art itself to the level of disposability. Today's newspaper could be tomorrow's fish-and-chip wrapper, but that should not be the destiny of a poem. So, like the avant-garde formation itself, their art sought to occupy—indeed, to create—a space *between* the 'high' culture of the dominant classes, and the 'low' culture of the dominated: an ambitious art, but alternative, like the professionalism that produced it; iconoclastic, but deeply serious, and committed to the modernist project of critically exploring—and often subverting—the dominant codes and conventions of symbolic representation, by making work in which such conventions were foregrounded. Thus Picasso's combination, in his experimental, light-hearted assemblage, of the readable (literally so, as newspaper) and the unreadable—and in this combination, the mimicking of the style of cartoons to make arms and hands—was his acknowledgement of the vitality of cartoon conventions.

The 1913 assemblage, with its acknowledgement of the force, and the attractions, of commodity culture, was a product of an engagement with the character and devices of that culture that was shared across the avant-garde formation, and that has been a constant thread running through its cultural practices and

creations for the whole of its existence. Indeed as we shall see, as commodity culture has grown in its scale, social reach, and power to shape our lives, its role in shaping not only the art, but the role and character of that avant-garde itself, has grown correspondingly. At the start of the last century, avant-garde artists in all media 'raided' popular idioms and conventions, and incorporated them into their experimental works, as a means of harnessing that vitality without simply capitulating to it. Thus Picasso's poet friend and champion Guillaume Apollinaire wrote, in the poem 'Zone' that opens his mould-breaking volume *Alcools* ('Alcohols'):

> You read handbills catalogues posters singing aloud
> That's what poetry is this morning and for prose there are the papers...

and punctuated this poem with declarations of his Catholic faith in terms that were deliberately, even provocatively, modern in their idiom:

> Here even the motorcars look like antiques
> Only religion is still quite new religion
> Remains as simple as the airfield hangars...
> It is God who dies on Friday and is resurrected on Sunday
> Christ climbing heavenward faster than aviators
> Holder of the world altitude record

'Zone' was written in late 1912, at the height of 'aviation mania'; a year or so later, Apollinaire had moved further towards popular idioms, with poems that he called 'calligrammes', and that— borrowing perhaps from the typographical innovations that Marinetti and the Futurists had pioneered—configured poems in the shape of things to which they referred, as in 'It's Raining' (Figure 8).

Film, too, was hugely attractive to the early avant-garde; inevitably perhaps, given its novelty as a medium, and the wild-fire spread of cinemas in cities across the world (in Paris there were three cinemas in 1900 and around 200 by 1914, by

8. Guillaume Apollinaire calligramme 'It's Raining', from
Calligrammes: Poèmes de la paix et de la guerre, 1913–1916

which time there were around twice as many in London and New York) but also, as film historian Tom Gunning notes, because of its popular origins in fairground and circus sideshows, and its radical difference—in the first decade of the twentieth century at least—from the narrative-driven conventions that governed mainstream theatre and would soon also dominate cinema. Until it did, early films comprised what Gunning calls 'a cinema of attractions': dominated by an enthusiasm for 'magical' illusions, direct stimulus (a train rushing straight out of the screen, for instance, which caused a stampede in at least one cinema), and exhibitionist confrontation of screen actors with the audience in the manner of music-hall. Gunning's term is borrowed from the early Soviet film-maker Sergei Eisenstein, who enjoyed the way that this emergent cinema aggressively subjected the spectator to sensual or psychological impact, and who adapted these features for the montaged juxtaposition of close-up shots and abrupt editing that characterized his pioneering films such at *The Battleship Potemkin* of 1925. Ballet, too, was quick to make use of popular themes and devices: Diaghilev's Russian Ballet, which, as I have noted, was a major catalyst across the practices of the avant-garde of the 1910s, presented *Parade* in Paris in 1917 to scandalous effect. Based on the promotional event outside a circus Big Top that was designed to draw an audience inside (a subject addressed thirty years earlier by Seurat, who was among the first artists to adopt commodity culture's idioms), *Parade*'s set and costumes by Picasso (reprising the style of the assemblage with which this chapter opened) and music by Erik Satie both plundered the popular for their features: the costumes were made of cardboard, the score included the noise of typewriters and foghorns, and snatches of jazz music.

Avant-garde and commodity culture: theorizing the relationship

What are we to make of this embrace by avant-gardists of commodity culture? To return to my questions at the start of this

chapter, what does it tell us about the cultural and social position of that newly consolidated avant-garde? And has this position changed, in the century since then? In a seminal essay of 1983, art historian Thomas Crow suggested that the artistic avant-garde should be seen as a 'resistant subculture'. Crow drew on recent analyses of British working-class youth subcultures, such as those of 1950s teddyboys or 1960s mods, who took sartorial styles from dominant, middle-class culture and reworked them into symbols of a resistance to that culture that also marked, implicitly, a resistance to its broader social and political authority. And he argued that the avant-garde's borrowing of what he called 'exotically low-brow goods and protocols' for its creations was an equivalent of such symbolic resistance; that these creations were 'a message from the margins' not only in the inclusion of this 'intruder' material, but in the manner of its use in their work as well—the appropriation of the qualities of that material serving to contest the rules of (high) art. Between the lines of this argument can be seen a suggestion of the *politically* oppositional character of that early avant-garde formation, a self-positioning as beyond the pale of mainstream culture, its 'alternative professionalism' developed as a means to a more fundamental kind of alternative.

Against this emphasis, the French sociologist of culture Pierre Bourdieu offered (in his book *La Distinction*, of 1979) an understanding of that borrowing of popular-cultural motifs as a means by which the avant-garde sought to gain power and status *within* mainstream society, not against it. 'Intellectuals and artists', he argued, 'have a special predilection for the most risky but also most profitable strategies of distinction, those which consist in asserting the power, which is peculiarly theirs, to constitute insignificant objects as works of art or, more subtly, to give aesthetic redefinition to objects already defined as art, but in another mode, by other classes or class fractions (e.g. kitsch)'. Avant-garde artists, says Bourdieu, are part of the dominated fraction of the dominant class, and their embrace of artefacts and qualities and experiences that are scorned by its dominant

fractions, the cultural mainstream and their patrons, is a means of using such authority as they have *as* artists (what he calls their 'symbolic capital') to raise their social status.

How do we choose between these two contrasting interpretations? Actually, they are both right, in different ways, for two reasons. First because there *were and are* contradictions (as I noted in Chapter 1) within the concept and the formation of the avant-garde: between a commitment to opposing capitalist society and its values and an aspiration to lead and shape them; between the imperatives of consumerist innovation and the refusal of its values. As we shall see in the next chapter, these contradictions— indeed the difference (which I shall suggest they register) between the formation of the avant-garde and the ideology of avant-gardism— have become quite fundamental over the last fifty years. And second, because, as Crow suggests later in his essay, there was a pattern in this avant-gardist borrowing that was repeated over the twentieth century: the moment of borrowing, he says, 'is followed by retreat—from specific description, from formal rigour, from group life, and from the fringes of commodity culture to its centre'. Thus Picasso recuperated his pasted-paper innovations for painting by imitating them in oils a couple of years later; Stravinsky subjugated his jazz rhythms to the demands of their orchestral contexts. 'And this pattern', he adds, 'marks the inherent limitations of the resistant subculture as a solution to the problematic of a marginalised and disaffected group.' In the end, Crow concludes pessimistically, the avant-garde functions 'as a kind of research and development arm of the culture industry'; not only no longer oppositional, but, more than this, an indispensable means of searching out 'areas of social practice not yet completely available to efficient [market] utilisation' and making them so.

Does the history of the avant-garde's embrace of commodity culture since the early twentieth century bear out this bleak analysis? A detailed answer to this question would take a book in

85

itself (and has, indeed, spawned several such books already), but we can note some moments in this trajectory. In music, perhaps the first avant-gardist musician, Erik Satie, Conservatoire-trained composer turned Montmartre cabaret piano-player, around the turn of the twentieth century borrowed themes and motifs from the popular material he was playing nightly, added to them snatches of the jazz that was then newly crossing the Atlantic, and inaugurated a kind of music that deliberately sat on the fence between 'high' and 'low' culture. The 1903 *Trois Morceaux en forme de poire* (Three Pieces in the Shape of a Pear)—which had neither three parts nor anything to do with pears—blended cabaret sprightliness with orchestral sonorities. Nearly two decades later, with the young composer Darius Milhaud, Satie invented 'furniture music', composed to be played in concert intermissions, not to be listened to attentively but intended to be comforting—the forerunner of that 'muzak' which is nowadays almost inescapable in public commercial spaces. Across the arts, from the middle of the First World War, the several Dada groups whom I discussed in the last chapter all took up, in different ways, either the Futurist play with the innovations of music-hall or the Cubist use of collaged non-art materials for the purpose of undermining that 'bourgeois rationality' that was their common enemy. Thus in Zurich it was Futurism and music-hall, as Ball and Hennings and friends staged their nonsense performances; in New York, Duchamp and Picabia subverted art's conventions in their introduction of everyday objects (Duchamp's *Readymades*) or blueprint-like drawings of machine parts (Picabia's *Young American Girl*); in Berlin, many of the Dada group turned Cubist collage into photomontage, borrowing photographic images from a wide range of popular sources, and gave it a sharp political edge. From the mid-1920s, artists in the Surrealist movement, in their turn, subverted everyday objects or images by juxtaposing them as irrationally—and often disturbingly—as possible: a lobster replacing a telephone receiver, in Dali's famous work, or a woman's face replaced by her nude torso, as in Magritte's painting. In all of these engagements by the avant-garde with commodity

culture we can see the origins of devices and techniques that have since become standard within commodity culture itself; most commonly in advertising, whose relentless harnessing of our dreams to sell our desires back to us has led its 'creatives' to draw tirelessly on the experimental work of the avant-garde. These developments would seem to underwrite Crow's prognosis.

In other avant-garde borrowings from popular culture, though, a different dynamic can be identified. At the same time as Surrealism's birth, other sectors of the Parisian avant-garde formation were seized by a mania for the culture of black Americans, especially jazz; 'negrophilia', as this seizure was called, combined myth-making and latent racism in equal measure, confusing America with Africa and primitivism with modernolatry as it thrilled to the 'otherness' of blues rhythms and Josephine Baker's dancing as both up to the minute and quintessentially 'African'. Music historian Bernard Gendron has shown how Darius Milhaud's score for the Swedish Ballet's 1923 production *La Création du monde* ('The Creation of the World'), with sets by Fernand Léger and libretto by Blaise Cendrars, exemplified this avant-garde milieu's assimilation of the musical particularities of jazz, its tempi derived from those of 1920s American jazz bands and their syncopated rhythms; while Jean Cocteau's spectacularly successful restaurant-bar Le Bœuf sur le Toit fashioned a middle-class 'bohemia' that turned such avant-garde 'negrophilia' into conspicuous consumption: 'Le Bœuf', argues Gendron, 'was in effect the middle term of a syllogism linking the signifier "jazz" to the aesthetics of Cocteau's centrist avant-garde.' While Paris's moment of infatuation both with jazz and with black culture was transitory, it not only established a relation between a complex and lively popular subculture and the experimentalism of the avant-garde, but marked the beginnings of the *reciprocity* of this relation—that is to say, the moment not only when, in Bourdieu's terms, artists could gain social advantage by redefining jazz as art, but when jazz musicians, too, saw the benefits of such a redefinition.

It was in the USA, however, that this reciprocity was first realized, and in particular in New York. The city was a cultural and social cauldron in the 1930s, as the influx of European refugees from Nazism, including many of its leading avant-garde artists, both brought the richness of that continent's modernist culture to the USA on an unprecedented scale, and thereby stimulated a heightening of avant-gardist activity that would see New York supplant Paris as the capital of the avant-garde in two decades. The city's first full-frontal encounter with European modernism brought about, in effect, a reprisal of the ferment of pre-1914 Paris, but with some crucial differences. One was that the grouplets and coteries that made it up were working in the cultural capital of the most powerful economy in the world, with a depth of wealth, and a class of plutocrats with an appetite for cultural philanthropy, that were unmatched elsewhere. Another, connected to (indeed a product of) this was that the newly founded (in 1929) Museum of Modern Art provided a key resource for avant-garde artists of all kinds (expanding over the next decade from its initial focus on fine art to include architecture, design, photography, and film), as well as a vehicle for the legitimizing and eventual institutionalizing of their work, and a stimulus to the city's contemporary fine art market. And a third was that American avant-garde artists of all kinds saw European modernism, and its newly arrived representatives, as at once an example and a challenge, to both of which they responded energetically. Together, these factors gave unprecedented momentum to cultural experimentation and innovation, in a city that already possessed not only a lively avant-garde formation— active at least since the immediate pre-First World War years— but, more particularly, a vibrant popular (and increasingly, commodity) culture. One of the particularities of this culture was jazz: with its roots in southern black folk culture, and its continuing largely black community of musicians (although its audiences, and especially the magazines and critics that supported jazz, were from the 1930s increasingly dominated by white fans), jazz was at once the most dynamic component of inter-war US

popular culture and, because of the institutional racism of high culture, the least able to access the latter.

But as Bernard Gendron details, the jazz world of the 1940s was embroiled in two factional wars that resulted in a re-positioning of its music: the first between the traditionalists of New Orleans-based 'dixieland' and the commercialized, big-band jazz of 'swing', the second between swing and the complex, difficult jazz of 'bebop'. Having seen off the retro challenge of traditional jazz, swing found its blatant commercialism challenged by the more cerebral innovations of Dizzy Gillespie, Charlie Parker, and others who borrowed from European avant-garde music. As Gendron notes, 'the historical transition of jazz from an entertainment music to an art music, initiated by the bebop revolution in the mid-1940s, set in motion a fundamental transformation in the way in which the barriers between high and mass culture would henceforth be negotiated. Before then the interchanges between high and low were decidedly one-sided, as modernists eagerly appropriated materials and devices from a more passive mass culture that was hardly aware of being pilfered or hardly cared. With the bebop movement and since, mass culture has been more the aggressor in this interchange... Rock music, film, MTV and advertising have liberally scavenged from a whole store-house of avant-garde devices and practices.'

Avant-garde as brand enhancement

This shift in the balance between directions of borrowing between avant-garde and commodity culture can be illustrated by a telling pair of photographs from almost the same moment (Figures 9 and 10). In the first, of 1950, Jackson Pollock is making one of his by-then notorious 'drip' paintings, pouring and flicking household enamel paint from a can onto a huge canvas lying unprimed and unstretched on the floor, a way of working (it quickly became known as 'action painting') that has been seen as an attempt to restore to the act of painting something of the rawness and psychic charge of

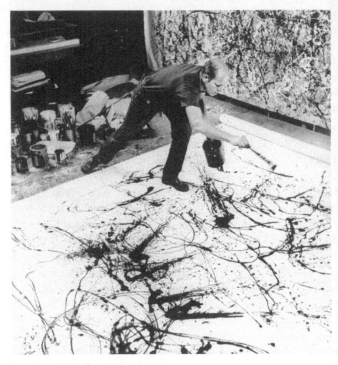

9. Jackson Pollock painting, 1950

primitive mark-making, in the face of—and as an attempt to evade the reach of—mechanized commodity culture. But the second, from the following year, is a photo from a fashion shoot by Cecil Beaton for *Vogue*, in which a model poses in the latest frock in front of just such a Pollock, showing that such evasion was by then already doomed to failure. From this moment on, we could say, avant-garde culture was torn between a retreat behind the stockade of 'high' art and a capitulation to the seductions, and the dynamism, of a 'low' commodity culture that now had the cultural upper hand. As to the first: art critic Clement Greenberg had written an influential essay in 1939, 'Avant-Garde and Kitsch', arguing that the only chance for what he called 'the only living culture we have now' to survive the

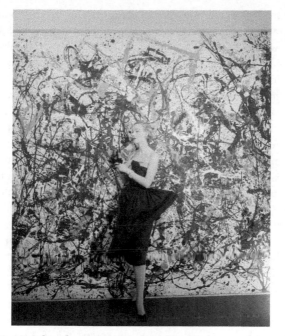

10. A fashion shoot by Cecil Beaton for *Vogue*, 1951

embrace of what he called the mechanical, formulaic, and ersatz 'kitsch' culture of the commodity was to assert its autonomy—for artists in all media to 'turn inward' towards the properties specific to those media, the devices and effects that gave each its distinctive qualities and value; to make art (in the broadest sense) exclusively about art, in sum. Greenberg's aesthetic views became increasingly influential through the 1940s and 1950s, as institutions and patrons of modernist culture found them conducive to their social interests in maintaining just such a distinction between 'high' and 'low' culture, or between (in the language of the time) 'highbrow' and 'lowbrow' tastes, and his argument thereby provided the criteria for the assimilation of this self-referential, 'autonomist', avant-garde art by the institutions of the dominant class culture.

As to the second temptation, that of capitulation to commodity culture: in the post-war boom decade of the 1950s in the USA, when wartime manufacturing turned from cruisers and tanks to Cadillacs and televisions, and the pent-up wartime savings of the middle class at last found their objects of desire, this consumer-driven economy produced an 'aesthetics of plenty' whose vibrant advertising imagery was both unmissable and irresistible. Artists across the world were drawn to it, like Picasso and the early century's avant-garde, but now not so much to raid it for motifs and devices as, like moths to a flame, to become one with it—and the closer they were, the more they succumbed to its heat. From the distance of war-scarred West Germany, painters such as Gerhard Richter and Sigmar Polke could bring some critical irony to bear on 'pop' culture, as the English artist Richard Hamilton named it. In austerity-straitened London, Hamilton himself, sculptor Eduardo Paolozzi, and others (including writers and architects) formed the 'Independent Group' that met in the Institute of Contemporary Art in the early 1950s to share and swop their enthusiasm for American pop culture. Their 'anorak-ish' passion for, say, Chrysler tailfins was combined, however, with an acute awareness of the constraints of the continued rationing of consumer goods that produced a wry, envious exaggeration of America's consumer cornucopia. In the USA itself, though, artists seemed too close to this to obtain much critical distance, and (although with significant exceptions, and to varying degrees) American Pop Art was characterized more by hedonistic immersion in 'pop culture' than by any critical take on it. Predictably perhaps, this capitulation to the commodity was embraced by the art market's dealers and collectors alike, and eventually produced its theoretical rationale, in the form of a postmodernism for whose apologists the 'marriage of commerce and culture' was a liberation of art from the ghetto of self-absorption and austerity that it had been led into by the insistence of Greenbergian doctrine on modernism's autonomy and self-referentiality. For such commentators, pleasure replaced purity at the top of the cultural agenda.

The avant-garde, as a cultural formation, was thus significantly institutionalized by the late 1960s, co-opted either by commodity culture itself or by an art world with an interest in sustaining an autonomous cultural resistance to it. The originary idea, too, of art itself as in the vanguard of society, showing it the way forward by the light of its imagination, as (in their different ways, as we have seen) both Shelley and the Saint-Simonians conceived it, had declined into either a 'high' culture whose necessary self-referentiality insulated it from contamination by 'kitsch' at the expense of social relevance, or a dystopian caricature of those hopes of an integration of art and society. As the literary historian and cultural theorist Terry Eagleton suggested at the mid-1980s moment of postmodernism's height of fashionability, this was a 'sick joke at the expense of revolutionary avant-gardism'. And since then, as we shall see, these two options have fused once again in the concept of the 'creative industries', whose supposedly Midas-like capacity to reinvigorate national economies is a current governmental obsession the world over.

We should be careful, however, not to see this co-option only from the side of the avant-garde itself, or we shall lose sight of a fundamental development. The Beaton fashion shoot, like the bebop movement in jazz, showed not only that avant-gardist attempts at evasion of commodification were futile, but also that avant-garde culture already had an allure that the industries of popular and commodity culture, and their customers, found glamorous. No longer beyond the pale of mainstream taste, as too provocative, or unseemly, or pornographic, or political, avant-gardism's deployment by *Vogue* to enhance the appeal of its fashions registered a general awareness that, shorn of these impediments, avant-garde art, even if it was incomprehensible, had connotations of intellectualism and of 'elite' taste that could be used to move, and keep, a brand up-market. This, after all, was (as I have noted) the social, as opposed to the aesthetic, meaning of Greenberg's insistence on an 'autonomist' mission for avant-garde artists, and there was no reason why it could not be appropriated by the

consumer industries themselves. It is a development that has functioned to co-opt not only avant-garde art but the concept 'avant-garde' itself for that very commodification against which, since the Romantic period, art has stood in opposition—and is also both a reprise, and a taking to another level, of that contradiction between the imperatives of consumerist innovation and the refusal of its values that I noted in Chapter 1. Overwhelmingly, since this mid-twentieth-century moment that the Beaton *Vogue* shoot registered, for the general public the term has come to stand for novelty, innovation, and imagination, not as alternatives to, but within the frame of, consumerism itself—as is shown by the list of its applications in every field from hair design to lifestyle coaching with which this book began. Indeed, as 'Fordist' mass production of goods in vast quantities for relatively uniform markets has given way to 'post-Fordist' niche marketing for a more diversified range of consumers, so the competitive edge provided by the epithet 'avant-garde' has become more widely recognized.

The postmodernism of the 1980s brought these reciprocal aspects of the avant-garde's co-option together, blurring the boundary between art and kitsch on which both inter-war avant-gardes and Greenberg's redefinition of them had, in different ways, depended, and opening the way to the wholesale assimilation of the concept of cultural creativity to the requirements of the market. Thus, to update the Beaton *Vogue* shoot: at the haute couture end of the fashion industry today, where designs for catwalk display exist in the pure air above that need for usefulness which contaminates high street fashion, designers make 'concept' collections that draw on adjacent fine art explorations of 'the body' (such as Rei Kawakubo's 'Lumps and Bumps' collection of the mid-1990s for Comme des Garçons, which incorporated rolls of padding to distort the body profile of its female wearers). Thus, reciprocally, artist Lucy Orta, herself a former design consultant in the fashion industry, also in the 1990s created a range of *Refuge Wear*, clothing that drew upon the contemporary growth in, and popular awareness of, the number of displaced and homeless people,

transforming textiles and fabrics into 'portable architectures' in which individuals can survive alien conditions. This work developed from 1993 into *Refuge Wear City Interventions* (Figure 11), a series of happenings in public places aimed at bringing to light situations of social and personal discomfort. For all the social conscience manifested in such work, it remained securely anchored in a gallery system which documents, publicizes, and markets such activities; postmodern to its hollow core, it turned social or political disadvantage into a spectacle in the very act of making it the object of its art. And thus, more recently, hybrid spaces between such cross-overs have proliferated, in which the distinctions between art and lifestyle practices and products are hard to discern; one example of many such is delineated on the website *The Avant-Garde Diaries* at <www.theavantgardediaries.com>. Initiated and sponsored by Mercedes-Benz, this 'digital platform' offers, in the words of its own blurb, 'to see through the eyes of people, who we admire for what they do'. It explains that 'for each article we ask contributors from the creative field to introduce someone or something they consider to be ahead of time and explain why ... Corresponding to this digital platform, three-day festivals will be hosted in metropolises around the world. Each event will be curated by an expert from the creative industry, showcasing his or her personal view on avant-garde.' Cars are nowhere mentioned.

But the avant-garde formation was never monolithic; as I showed in Chapter 2, it was a motley network of groupings pressed, by a combination of forces (those social dynamics of the post-First World War world that I outlined) into different, sometimes conflicting, shapes and positions. Within the New York grouping of the network, the market and institutional factors shaping the formation were accompanied by political aspects of that late 1960s conjuncture: the Vietnam war, the civil rights movement, the Soviet invasion of Czechoslovakia, the rise of the women's liberation movement, the murder of two Kennedys and Martin Luther King. At the same moment, the first generation of artists on both sides of the Atlantic to be educated in universities, and to

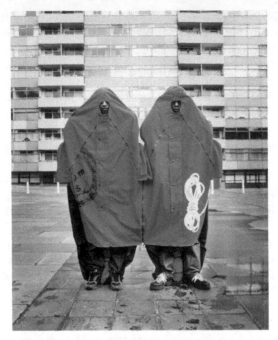

11. Lucy Orta, *Refuge Wear City Intervention*, 1998

include art history in their studies, found their way to that early 1920s moment of Soviet avant-garde experimentation that had been excised from the history books by Cold War ideology. One result of all of this was the politicization of many artists, for whom the Russian Productivist experiments (with turning art to social purpose) that I noted in Chapter 2 were both a model, and a means of re-connecting with the libertarian aspirations of Shelley's originary avant-gardism. Alongside, and often in opposition to, both the capitulation to pop culture and the elitist refusal of it, there emerged within the avant-garde a range of energetic, alternative, often angry cultural expressions, that ran from esoteric and/or neo-Dada experimentalism, such as the explorations of chance and the inclusion of random noise in the

work of composer John Cage, through folk-rock music, radical film, theatre, and dance to explicitly political art, some of it the product of collaborative work. The late 1960s were thus not only the moment of the capitulation of the avant-garde to commodity culture and its institutionalization by the cultural 'establishment', but at the same time that of the re-assertion of avant-gardism as an ideology, a war-cry against a capitalist society and its culture that were perceived to be rampant, callous, and complacent.

We should note, finally, that the avant-garde's engagement with commodity culture must be seen as more complex than the notion of 'capitulation' allows, for that culture was driven by more than consumerism alone. Whilst the overriding motivation for technological innovation in the making of consumer goods is usually, in the last analysis, the profit motive, such innovation has often a degree of autonomy that brings its own momentum; thus, for instance, the internet's astonishing proliferation, and the emergence of social networking sites whose success has been so remarkable and of such social, even political, consequence. Thus too the developments in computer-generated cultural products across a wide range, from music to design. One aspect of this is that move towards convergence of cultural forms and practices that has led, for instance, composers increasingly to make their new music in the form of 'underscores' for gaming products, and film-makers to make promotional music videos. On the eve of the Second World War, as we have seen, Clement Greenberg railed, in his essay 'Avant-Garde and Kitsch', at a tidal-wave of what he saw as a corrosive culture of mediocrity characterized by just this hybridity, or convergence, which current technological innovation is driving, and argued that the role of the avant-garde was to resist it through introspective reflection on the properties of each specific cultural medium. Today, this effort would seem to be as futile as Canute's. Has Greenberg been disproved, or simply drowned? That is, has his argument simply been submerged by the rising tide of the technology-driven convergence of the arts, or are there opportunities for critical, oppositional practices or gestures *within* this?

Chapter 4
The avant-garde and revolution

Partial definitions

Eugène Delacroix's painting *Liberty Leading the People* of 1830
(Figure 12), in the Louvre, is perhaps the most enduring image of
revolutionary insurrection in the history of art. And deservedly so:
its dramatic representation of a martial, dishevelled, and comely
Liberty brandishing the *tricolore* and accompanied by a motley
crowd of Parisians, among whom is the top-hatted figure of the
artist himself, at the height of 'les trois glorieuses'—the three
'glorious days' that toppled the Bourbon monarchy in July of
that year—captures, indelibly, at once the delirious optimism of
the revolutionary moment and the libertarian instincts of all
artists with nothing to lose but their chains of social and
cultural marginalization. It is thanks greatly to resonant images
such as this that the idea of the avant-garde, as the representative
of such artists, has become almost inseparable from that of
political activism; indeed, from 'left-wing', and usually
revolutionary, politics. Moreover the emergence, with the launch
of Neo-Impressionism in 1886, of the first nucleus of an avant-garde
in the modern sense, of a group of self-consciously and distinctively
innovative artists, was itself shaped in part by their affiliation to

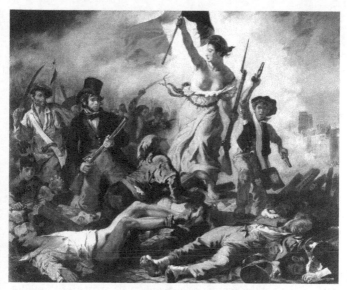

12. **Eugène Delacroix, *Liberty Leading the People*, 1830**

the leftist political movement of anarchism, and it was anarchists such as the Neo-Impressionist painter Paul Signac who founded in Paris, in 1884, the juryless, populist Salon des Indépendants that became a cardinal point of reference for the nascent avant-garde network across Europe before 1914.

This understanding of the avant-garde as, more or less by definition, both culturally and (left-) politically activist is, however, partial, in both senses of this term: as being incomplete and also partisan. As to the partisanship, this chapter will show that it owes its present ubiquity in some quarters to the political upheavals of the late 1960s on both sides of the (then current) Cold War. First, though, we need to note its incomplete character. For as art historian Paul Wood observes, it is an interesting fact that the Saint-Simon and Shelley versions of the role of the artist were

followed within a decade or so by a different understanding of art, that of 'art for art's sake'. Its initial proponent was the writer Théophile Gautier, whose 1835 Preface to his novel *Mademoiselle de Maupin* argued that 'The useless alone is truly beautiful; everything useful is ugly since it is the expression of a need, and man's needs are, like his pitiful, infirm nature, ignoble and disgusting. The most useful place in the house is the latrines.' Whilst Gautier made no reference either to an avant-garde or to art as avant-garde, his view of art is clearly opposed to those of Saint-Simon and Shelley—and insofar as the concept of an avant-garde *within* art included a sense of that avant-garde as separate from the mainstream, it absorbed Gautier's emphasis along with that of the other two; hence that tension between assertions of its autonomy and claims for its leadership of society at large.

But the assumption of a necessary relation between the cultural avant-garde and left politics is misleading as well as incomplete, because the political activities of avant-garde artists (of all kinds) have included *other* politics than only those of the left. As the cultural historian Raymond Williams observed, the avant-garde of the late nineteenth and early twentieth centuries defined itself partly in terms of its opposition to 'the bourgeoisie'—an opposition which could be voiced from different (including politically incompatible) positions. Thus, the bourgeoisie could be vilified from an aristocratic position for being 'worldly and vulgar, socially pretentious but hidebound, moralistic and spiritually narrow', whilst 'for the newly-organising working class...not only the individual bourgeois with his combination of self-interested morality and self-serving comfort, but the bourgeoisie as a class of employers and controllers of money, was at centre stage'. In 1890s Paris, the group of artists, among them Pierre Bonnard, Édouard Vuillard, and Félix Vallotton, who adopted the name 'Nabi' (Hebrew for 'prophet', an implicitly avant-gardist self-styling if ever there was one), included the painter Maurice Denis, a devout Catholic whose politics, always on the right, hardened over the turn of the century into support

for the anti-Semitic, monarchist Action Française. Denis, who acted as the spokesperson for the Nabis, had in 1890 written (at the age of 20) a keynote essay, 'Definition of Neo-Traditionism', that was a rallying cry for a return by avant-garde artists to the consecrated values of a classicism that stood for a social as well as aesthetic, hierarchical order.

In another register, the poet Marinetti's promotion, via the assertively avant-gardist Futurist movement that he founded in 1909 in Italy, of a masculinist modernolatry anticipated Fascism by a decade. 'War is the only hygiene', he declared in a 1915 manifesto fuelled by belligerent nationalist fervour, and in the 1920s he became an active, globe-trotting apologist for Mussolini's regime. His belligerence was shared in the months before August 1914 in London—indeed imitated, since Futurism was by then notorious—where the writer and painter Wyndham Lewis and the poet Ezra Pound led the founding of 'Vorticism', a cross-disciplinary 'ism' grounded in a muscular, jingoistic English patriotism (although Lewis was born in Canada and Pound was American) and celebration of the hard, machine forms of modern industries and cities. Self-consciously and quarrelsomely avant-gardist, both men moved steadily further to the political right in the inter-war decades, arriving eventually at support for Hitler.

Not all of the 'other' politics of the avant-garde were either as extreme or as explicit as those of Denis, Marinetti, Lewis, and Pound, and indeed in the inter-war period the political connotations of the concept of the avant-garde were seen in directly opposed ways from the capitalist and Communist camps. As Paul Wood has noted, the avant-garde 'got shot at from both sides': given the upheaval and uncertainties of the Depression years that followed the crash of 1929, its subversive and leftist associations were uppermost in the west, whilst the defensiveness of Stalin's emergent Soviet empire in the face of the hostility of capitalist governments led Communist parties within it to stress the 'bourgeois' patronage, and thus character, of avant-garde

culture. And as we have seen, in the case of the signatories of the 'Proletarian Art Manifesto' in 1923, this hostility from the leftist *political* avant-garde led these artists to critique sharply both the bourgeois tastes of the working class and the encroachment of Bolshevik politics on their own aesthetic liberties.

Avant-garde and modernism again

It was this developing awareness, on the part of many artists of the inter-war avant-garde formation, of a collective identity grounded in such aesthetic liberties, that can be seen to have drawn many of them away from the political affiliations that characterized the Neo-Impressionist circle in which that formation originated. The liberties, as I have suggested, were those of an 'alternative professionalism' centred on craft inheritances, aesthetic principles, and a supporting infrastructure (of dealers, publishers, critics, impresarios, and patrons) that were all increasingly distinct from those of the mainstream arts world. The very consolidation of this formation around such professionalism –that is, the *process of professionalization* itself that the cultural avant-garde shared with the members of other occupations, in that developing division of labour and monopolization of specialist knowledges that characterized western societies from the late nineteenth to the mid-twentieth centuries—can be seen as amounting to an *institutionalization* of it. By institutionalization, I mean something like a hardening of its arteries: the steady establishment of rules and protocols, and the corresponding loss of informality, and perhaps even of the capacity for experimentation that characterizes a social and cultural grouping at its outset.

If such a process of formalization (as it might be called) of initially informal groupings is a recognizable pattern of their development, though, it was not entirely self-generated in the case of this cultural avant-garde. The political, social, and cultural dynamics of the inter-war period, and in particular the growing face-off

between capitalism and Communism, played their part not only in drawing avant-garde artists (of all kinds) away from explicit political affiliations but also in separating the formation of the avant-garde itself from the principles and motivations that characterized the concept at its outset a hundred years earlier. When, with the rise of Nazism, European artists exiled themselves to New York and that city began to become the centre both of an internationalized avant-garde and of an increasingly internationalized capitalist system, the institutionalizing of the first of these—its co-option for the needs of those who ran the second—gathered pace. Alfred H. Barr, the first director of the city's Museum of Modern Art (founded in 1929), presented through the 1930s an influential programme of exhibitions that effectively redefined modern art in apolitical terms, stripping out all references to a world outside of art from a history that marshalled Cubism, abstraction, Dada, Surrealism, and most of the other 'isms' of the first third of the twentieth century into a mappable, self-contained genealogy of modernism (Figure 13). In this graphic representation of that narrative, which was the frontispiece for the catalogue of a major MoMA exhibition of 1936 entitled *Cubism and Abstract Art*—and which became so influential that this catalogue was still being reprinted fifty years later—the dates at the sides mean nothing, as there is no link whatsoever between them and the art they bracket.

As I noted in the Introduction, there has been a close relation between 'avant-garde' and 'modernism' throughout the history of both concepts. For artists in all media, modernism was the term that came to be used for the ways in which they symbolized and articulated their responses to their experiences of modernity, most often through an engagement with the characteristics specific to their chosen media, and an exploration of how aspects of that modernity were calling the conventions and devices of these media into question. The ways in which this 'interrogation' was conducted were avant-gardist insofar as they were motivated by an awareness of aesthetic positions, oppositions, and alternatives within the field of

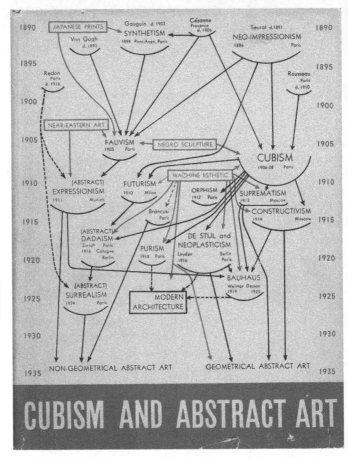

13. Alfred H. Barr, *Cubism and Abstract Art*, used on the cover of an exhibition catalogue at MoMA, 1936

modern art-making: of the cultural spaces in that field in which a novel was written and published, say, or a symphony composed and performed, a film made and screened, or a picture painted and exhibited; and the relation of these contexts to other social spaces. Modernist art (in its broadest sense) was thus shaped by the character of the particular avant-garde grouping within which it was

made, and could, as a result, take a variety of forms. As we saw in Chapter 2, for artists of all kinds in that inter-war period, in avant-garde circles for which the Russian revolution was an inspiration and the political context of their work pressed an urgent non-art agenda, the 'interrogation' of the conventions of representation often had a political edge. Constructivist painters, playwrights, sculptors, and poets in Russia itself, the Berlin Dada group, others in Hungary, Poland, and elsewhere used their modernism for political ends. One influential example was the technique developed by the German playwright Bertolt Brecht of staging his epic dramas, such as *Mother Courage and her Children* of 1939, in such a way that its audiences could never ignore the fact that they were watching a representation by actors, and were encouraged to relate the events of the play to their own situations rather than escape into the make-believe of conventional naturalistic theatre.

The redefinition of modernism that was begun by Barr, and which his chart of 1936 represents, discarded these politically inflected modernisms in favour of a single modernist project of self-sustaining and self-regarding aesthetic introspection. If this was only implicit in that chart, it was made explicit a few years later by the critic Clement Greenberg, whose seminal essay of 1939, 'Avant-Garde and Kitsch', argued, as I have noted, that the only chance for (what he called) 'the only living culture we have now' to survive the embrace of (what he called) the mechanical, formulaic, and ersatz 'kitsch' culture of the commodity was to assert its autonomy—for artists in all media to 'turn inward' towards the properties specific to those media, the devices and effects that gave each its distinctive qualities and value; to make art exclusively about art. Greenberg's essay became increasingly influential through the 1940s and 1950s, I suggested, as institutions and patrons of modernist culture found them conducive to their social interests in maintaining just such a distinction between 'high' and 'low' culture, or between (in the language of the time) 'highbrow' and 'lowbrow' tastes. We can add that it was equally effective in depoliticizing avant-garde culture,

and that Greenberg's argument, reiterated in another landmark essay 'Modernist Painting', of 1960, provided the criteria for the assimilation of this self-referential, 'autonomist', avant-garde for the Cold War cultural politics of the US political elite (which, as I noted in the Introduction, juxtaposed its depoliticized aesthetic freedoms with the political shackles of Soviet culture, as part of the American programme of cultural propaganda—thus, ironically, using for political purposes an Americanized modernism whose apparent autonomy was central to its very consecration). Together with the celebration of the vitality of America's commodity culture that was Pop Art, by the mid-1960s the purging of the formation of the cultural avant-garde of any contamination by an oppositional politics, at least in modern art's new capital, seemed complete.

Other definitions, other criteria

But no hegemony, or dominance, whether cultural or political, is ever complete; and history never stands still. The 1960s saw also the surfacing into visibility of radical ideas and energies not only in the USA but across the western world, as the deepening travails of America's war in Vietnam were mirrored in the Soviet bloc by the repression of Czechoslovakia's liberalization of Communism, and joined by struggles over civil rights for African Americans, the women's movement, and student uprisings in campuses on both sides of the Atlantic. These energies found expression within the formation of the avant-garde, across all of the arts and increasingly, around the world, both in a deepening antipathy to the commodification of its cultural practices and in a recuperation of that earlier moment of a multiplicity of politically inflected modernisms that Greenbergian doctrine had excised. To take the second of these first: over the course of the 1960s, the arts— especially the film, photography, theatre, literature, and fine art, as well as the associated theoretical writings—of the Russian avant-garde of the early 1920s, in particular, was progressively rediscovered, absorbed and built upon. It was so, because in its

brief but intense exploration of the relation between culture and Bolshevism (before both were snuffed out by Stalin) in this moment of explicit challenge to capitalism, that avant-garde grouping stood for an avant-gardist ideology whose lineage went back to Shelley, which had been buried by commodity culture and institutional co-option, but which might yet be recovered. The films of Sergei Eisenstein, Dziga Vertov, and Vsevolod Pudovkin, the theatrical productions of Vsevolod Meyerhold, the theoretical explorations of the Moscow linguistic circle, the semiotics of Valentin Voloshinov and Mikhail Bakhtin, the engagements of Productivist theorists such as Boris Arvatov and artists such as Karl Ioganson with industry and its needs (to single out just a few names), nourished the first of these expressions of avant-garde politics: a growing antipathy to the commodification of culture. In art, an avoidance (or interrogation) of the gallery-based, sellable aesthetic object stretched from the minimalism of artists such as Robert Morris and Donald Judd, through the 'land art' of the likes of Richard Long and Robert Smithson, and the conceptualism of Sol Lewitt or the Art & Language collective, to the institutional critique of Hans Haacke.

Most of these, however, were the work of individuals in their respective media, even though they may have been produced in the context of groups and even 'isms'. Alongside them there developed from the late 1960s a significant alternative cultural disposition: drawing also on the example of the Russian Productivists, but this time on the collectivist character of their work and organization as well as on their social and political engagement, increasing numbers of artists within the New York avant-garde community in particular (but elsewhere also) turned to collective arts practices—a development that marked a shift from a focus on art as a given institutional and linguistic construction, to an active intervention in the world of mass culture, often grounded in a specific politics and centred on specific campaigns. Among the first of these was the New York-based Art Workers Coalition, a large, broadly based, and

short-lived group formed in 1969, partly in response to the events of May 1968 in Paris (and as such, ironically, an acknowledgement of the continuing dominance, at least in intellectual-political respects, of that city's avant-garde). Its first action was a protest in the Museum of Modern Art against a violation of artists' rights by MoMA, and this was followed by dramatic 'actions' in protest against the Vietnam War and against the under-representation of artists of colour. While the AWC worked within the context of the art world, it shared the agit-prop street theatre strategies of radical political groups such as the anarchist Black Mask (later the Motherfuckers), and its activism was of a piece with that of many other radical political demonstrations of that time in the USA: the American Indian Movement occupation of Alcatraz Prison, the Weatherman bombing of the police memorial in Chicago. The feminist art movement also pursued its goals in collectivist ways, from the 1972 *Womanhouse* project in Hollywood, whose transformation of a suburban house highlighted the oppression of women by domesticity, through the mid-1970s *Dinner Party* project led by Judy Chicago, which elevated traditionally anonymous craft production by women to art status, to the mid-1980s foundation of the Guerilla Girls collective which highlighted and protested the under-representation of female artists in exhibitions. And as the AIDS crisis mushroomed through the late 1980s and into the 1990s, 'action cells' of artists, of which perhaps the best known was Gran Fury in New York, made collective art works to document its ravages and pressure health bureaucracies to take action.

The emergence of these collectivist art practices, whilst it was informed by the example of the politicized cultural avant-gardes of the inter-war period, did not in itself mean that they were all positioned in opposition to the cultural or social mainstream, or that they acted autonomously. As art historian Alan W. Moore has noted in a valuable survey of artists' collectives in New York City, the AIDS-oriented groups used the increasingly receptive art institutions as a means to bring their message to the public, and

the work they produced was often shown on public access cable television. The significance of such practices for a history of the avant-garde lies in their collective character itself, and in their orientation to social activism rather than the production of aesthetic objects that could be commodified. Of course, not all of these initiatives were equally resistant to commodification: the story of how the US 'counter-culture' of the 1960s, for example, for which San Francisco became an emblem was turned into consumerism is a now-familiar one, best told, perhaps, by Thomas Frank's *The Conquest of Cool* of 1997. And as I have suggested, the postmodernism that flourished in the 1980s was on one level a celebration of just this narrative.

But alongside it there developed another, critical postmodernism, less trumpeted by cultural journalists yet significant across the arts; one that the American cultural historian and theoretician Hal Foster outlined in a 1983 essay, describing it as 'a postmodernism of resistance [that] is concerned with a critical deconstruction of tradition, not a... pastiche of pop- or pseudo-historical forms, with a critique of origins, not a return to them'. In short, he declared, 'it seeks to question rather than exploit cultural codes, to explore rather than conceal social and political affiliations'. By the time that Foster wrote this, however, it was evident not only that the libertarian aspirations of the hippie counter-culture had been channelled into consumerism, but also that the avant-gardist hopes of political revolution that had, perhaps naively, been invested in the many-levelled upheavals of 1968 had not been realized—indeed, Foster's definition of a critical postmodernism can be seen as an attempt to provide a basis for a revised and scaled-down radical cultural-political agenda in light of that broader failure. It was accompanied by a redefinition of avant-garde art-making offered by another US-based cultural historian and theoretician (and Foster's colleague at the New York art intellectuals' magazine *October*), Benjamin Buchloh: such art, he wrote in 1984, was 'a continually renewed struggle over the definition of cultural meaning, the discovery and representation of

new audiences, and the development of new strategies to counteract and develop resistance against the tendency of the ideological apparatuses of the culture industry to occupy and control all practices and spaces of representation'. Buchloh's definition drew on a range of concepts—'ideological apparatuses', 'the culture industry', the struggle over cultural meaning, are some—that were the product of much Marxist theorizing about the relation of culture to politics in the post-Second World War decades. But it is significant that it rested, crucially, on an idea of avant-garde cultural practices as grounded in a politics of opposition to capitalism. As we have seen, little in the history of the cultural avant-garde as a formation, through the entire twentieth century, offered much support for this idea—with the exception of those groupings that allied themselves to political avant-gardism: before the First World War to anarchism and, immediately after it, to the Communist project in the new Soviet Union and in those societies who received its shock-waves. The idea did, however, connect—through such groupings—to Shelley's originary assertion of a libertarian cultural avant-gardism. We could say that the rediscovery of the history of the Russian artistic avant-garde served as a means to resuscitate an ideology of avant-gardism that had been all but suffocated by the institutionalizing of the formation itself.

In this effort of resuscitation, one publication was of unparalleled influence. The German Marxist cultural theorist Peter Bürger's short book *Theory of the Avant-Garde* was published in German in 1974, at the end of a half-decade in which theorists on the left had sought to come to terms with the failure of the revolutionary political hopes of 1968 by exploring and emphasizing the potential of cultural, as opposed to political and economic, practices and strategies for advancing revolutionary politics. A product of this 'cultural turn' as it was called, *Theory of the Avant-Garde* proposed a definition of the artistic avant-garde not in terms of its historical emergence and consolidation as a formation (as I have in this book), but in terms of that ideology of avant-gardism. What

(despite his avoidance of the history of the formation) Bürger called 'the historical avant-garde' were those art movements who 'do not reject individual artistic techniques and procedures of earlier art but reject that art in its entirety, thus bringing about a radical break with tradition', the aim of which is 'the sublation of art in the praxis of life' (in other words, the integration of art and (non-art) life). This definition included, strictly, only Dadaism, early Surrealism, and 'the Russian avant-garde after the October [1917] Revolution'. Mindful, though, of the incompatibility of this narrow definition with the actual history of the avant-garde, Bürger included Italian Futurism and German Expressionism 'with certain limitations', and, recognizing the impossibility of excluding Cubism (which, as I have argued, was a primary vehicle for the formation's consolidation), he added this movement too, although it had, as he acknowledged, none of the aims that provided the criteria for his definition.

For all its historical inaccuracy with regard to the history of the formation, *Theory of the Avant-Garde* presented the emergence of the avant-garde as Bürger thus defined it, as a necessary and inevitable product of the history of art (specifically, fine art, but by implication, all of the arts) in bourgeois society. As such, and in its explicit recuperation of the originary ideology of avant-gardism for radical, leftist politics, Bürger's book helped fundamentally to revitalize that ideology and reinvest the concept of the cultural avant-garde with a radical, critical edge—and it is this characteristic on which Buchloh builds *his* definition of avant-garde art practice; it is no coincidence that this is offered (but as no more than the passing remark I have quoted) in a review of the 1984 English translation of *Theory of the Avant-Garde*. Although it disagreed with Bürger's negative assessment of what the latter had called the 'neo-avant-garde' of the post-Second World War period (as having been co-opted by modern art museums— institutionalized, much as I have suggested, away from those aims of art/life integration and opposition to capitalism that distinguished his 'historical avant-garde' of the inter-war years),

Buchloh's warm reception of the book's definition of that historical avant-garde gave an authoritative precedent for others in the anglophone arts world, and Bürger's conceptualization of his subject, despite its profound shortcomings as history, has shaped subsequent understanding of both the concept and the formation. Particularly (and understandably) among cultural historians and commentators on the political left, the two are routinely confused, and the formation is assumed, axiomatically, to have always been engaged with revolutionary politics.

Yet avant-gardism was not resuscitated, nor was this mythic status of a left-political avant-garde created, by theory alone. If no hegemony, or domination, whether cultural or political, is ever complete, then neither, as I suggested in the last chapter, was the avant-garde formation itself ever monolithic. And if the transfer of the centre of its network to New York, and the reinforcement of this *as* its centre once again (concomitant with the mid-twentieth-century consolidation of the USA as the capital of capitalism) led, as we have seen, to its co-option within and for that capitalism, elsewhere there were other dynamics under way. For the counter-cultural community of the Parisian avant-garde, which had neither fully acquiesced in the transatlantic transfer nor wholly succumbed to that co-option, the aftermath of the Second World War was a battlefield of competing cultural groupings that sought first to take stock, and then to take advantage, of the complex inheritance of a part-defeated, partly collaborationist, and wholly traumatized former combatant nation. As the smoke of rhetoric cleared from that battlefield in the early 1950s, contingents of second-generation Surrealists and other 'isms' that had formed out of the break-up of Surrealism immediately after the war brought together the inheritances of that movement, and of a cultural Marxism that was a product of the involvement of intellectuals with the French Communist Party, into a loose re-configuration of the city's avant-garde battalion. Chief among these 'isms' were the Lettrist International led by Guy Debord, and the COBRA group of artists led by Asger Jorn (the acronym

combined the first letters of Copenhagen, Brussels, and
Amsterdam, whence its members originated). As cultural
historian Peter Wollen notes, the new configuration's project was
to re-launch Surrealism on a new foundation, stripped of its
by-then quasi-mystical and occultist thinking, and re-positioned
within the framework of cultural revolution. By 1957 it had found
a name—the 'Situationist International', or SI, as well as a degree
of stability that enabled it to survive (despite a series of
unusually—even for Paris—acrimonious splits and quarrels) until
the early 1970s, and a subsequent reputation that has increased
with every decade towards the mythic status that it holds today.
We must explore why it does, and what it implies for an avant-
garde, and avant-gardism, in the twenty-first century.

The avant-garde is dead, long live the avant-garde: the Situationists and their legacy

Art historian and cultural activist Gavin Grindon suggests that
'[p]erhaps, not accidentally, the moment of the radical avant-garde's
disappearance from art histories' (as a significant factor in those
histories, after its co-option in the ways I have suggested) 'is a
crucial moment of its success as a radical tendency'. For as he notes,
the maintenance by the avant-garde of critical purchase on social
and political change was often dependent on their refusing the role
of artists as conventionally understood. This certainly applies to the
Situationists. Central to the SI's thinking, and to its activities, was
an engagement with two concepts: the psycho-geography of the city,
and the role of art as play (and play as free, creative activity)—which
came together in an exploration of possible modes of
transformation of cities and the lives of their inhabitants. As Peter
Wollen summarizes its programme, '[a]rtists were to break down
the divisions between individual art forms, to create *situations*,
constructed encounters and creatively lived moments in specific
urban settings, instances of a critically-transformed everyday
life...as well as to agitate and polemicise against the sterility and
oppression of the actual environment and ruling economic and

political system.' The key tactics adopted were those of *dérive* (drift) and *détournement* (diversion), both of which involved treating the spaces and zones of the city not as functionally ordered, and separated in ways that prioritized the activities of work and the requirements of money-making, but as a playground for activities guided solely—as is play—by desire and the means for its realization. And underpinning both was a commitment to the refusal of *work* as the organizing purpose of individual and social life. For work represented the chains that Marx and Engels's workers of the world needed to cast off; if the avant-garde was to realize its potential to change society, it had to offer a model for an alternative.

This was hardly a strategy or set of activities with much revolutionary potential, we might be entitled to conclude; rather, just another position-taking gesture on the part of another groupuscule in the now-marginalized subculture of the Parisian artistic avant-garde. And indeed such might have been the verdict of history, had it not been that, as a result of the ways in which intellectual currents swirled around, merged with and gained momentum from political energies and aspirations, in a city with a long tradition of the engagement of artists and intellectuals in revolutionary upheaval (witness the Delacroix painting with which this chapter opened), the Situationists found themselves in May 1968 at the centre of the student unrest that shook France to its core. A political convulsion that briefly allied revolutionary thinking with the specific material demands of both university students (for more democracy in higher education) and Renault car workers (for higher wages, a shorter working week, earlier retirement, and greater workplace democracy) threw up, in the form of Situationist slogans, a rhetoric that captured the delirious optimism of a moment that nearly saw the fall of the French government: 'under the cobblestones, the beach', 'be realistic: demand the impossible', and 'all power to the imagination' were among the slogans that appeared on walls across Paris that month; their very familiarity to us, over forty years later, is

testament to their potency, as well as a recognizable referencing of Shelley's originary slogan that poets are the unacknowledged legislators of the world.

What was the legacy, though, of the Situationists beyond these slogans (themselves now co-opted for fashionista T-shirts across the world)? As Grindon notes, the SI's refusal of work stood in a tradition of artistic avant-garde refusal to participate in the production of capitalist values, of which the Berlin Dada group of *c.*1920 and the Parisian Surrealists through the subsequent decade are significant examples. The former in particular, he suggests, drew much of *their* commitment to the refusal of work from an already-existing struggle by the politically organized working class of Berlin against the prevailing conditions, and the culture, of their work, and took the example of the activism of contemporary social movements (in the revolutionary moment of 1918–19) as a model for their art practice. Grindon suggests, further, that 'in the mid-1960s, Berlin Dada's avant-garde approach to social movement forms and Surrealism's rhetoric of work-refusal would be combined by a less documented other neo-Dada emerging from European and American social movements, through groups such as the Provos, Kommune 1, Diggers, Yippies, Black Mask, and Chicago Surrealists'. And Grindon adds: 'These neo-Dadaists, who returned to the problem of reimagining the aesthetics of social movement forms of collective direct action, are the more immediate forebears of the contemporary art-activist "interventionism" practised by collectives such as the Yes Men, Reverend Billy, and the Church of Stop Shopping, Etcetera, the Laboratory of Insurrectionary Imagination, and the Centre for Tactical Magic.'

It is within one specific area of contemporary art-making, however, that of internet art, that the refusal, by several groupings in the inter-war avant-garde, of the role of artist as conventionally understood is perhaps most controversially reprised. As art historian Julian Stallabrass writes, 'many of the actual conditions of

avant-gardism are present in on-line art: its anti-art character, its continual probing of the borders of art, and of art's separation from the rest of life, its challenge to the art institutions'. Stallabrass suggests that 'to take effective action on-line is to gain power that can have immediate consequences in the off-line world'—a truth that was brought home to one internet artist with particular force when, as *The Guardian* reported in June 2004, the home of American Michael Kurtz was raided without warning by the US government's Joint Terrorism Task Force. Kurtz, a member of the Critical Art Ensemble collective of internet artists, was held for questioning for two days, while his house was cordoned off and searched, and his computer, books and private papers were confiscated. The Critical Art Ensemble is, in its own words, 'dedicated to exploring the intersections between art, technology, radical politics and critical theory'; in pursuit of these interests, Kurtz had in 2002 produced a work, *Molecular Invasion*, a statement against genetically modified crops, and it was apparently the combination in this work of experimentation with bacteria and the dissemination of results on the internet that prompted the government agency to fears of bio-terrorism. It is this striking sensitivity to incursions into the field of state and corporate activities that the Critical Art Ensemble and other like-minded Net art activists exploit. But such exploitations not only distance their activities yet further from art practice as conventionally understood; it collapses the difference between the cultural avant-garde and non-art 'guerrilla' assaults on capitalism and the state that commonly goes under the name of hacking. Is such a collapse the price to be paid by the cultural avant-garde for any participation in the process of legislating for the world?

Conclusion

Across the world, 'the creative industries' became in the first decade of the twenty-first century a ubiquitous term, a fashionable concept, and an apparent success story. Launched on the threshold of the millennium in Britain by the incoming New Labour government of Tony Blair with a 'Mapping Document' (1998) that listed thirteen such industries, the concept rapidly gained popularity and momentum in policy-making circles once it emerged that this collection of disparate cultural practices and their attendant structures of dissemination and marketing could, so defined, be seen as among the most dynamic sectors of the national economies of the advanced capitalist countries. In Britain it is second only to (as always) the financial sector in its contribution to the national economy (7.5 per cent of the UK's gross value added, according to recent figures). As a result, it quickly achieved a status as the instrument of choice for governments seeking to boost economic development. For it acted on several strategic levels: 'culture' could be harnessed in local, regional, and national arenas, to regenerate post-industrial inner cities, to attract tourism, to seed the growth of small businesses, to galvanize real estate development; not least, to give lustre to a national (self-) image: the 'Cool Britannia' concept promoted by Blair is an example, if a thankfully short-lived one.

In addition, the concept of 'creativity' itself was seen to have value far beyond its then-current usage: from the turn of the century, a stream of commissioned reports and policy papers made the argument for the benefits of greater awareness of creativity in business. At the same time, corporate business leaders recognized the economic potential, at a time of falling profits and rising fixed costs, of borrowing from the artistic avant-garde formation those features of its characteristic way of working, and indeed living, that enabled its survival on the most slender of means. Among these are the blurring of the 'work/life' division (commitment to cultural practice brings its own reward, and is as much a hobby as a job); acceptance of relative poverty and economic insecurity in return for such job satisfaction, independence, and self-employment; a way of working from project to project, each on a short-term basis, rather than regular employment; the self-funding, rather than employer-funding, of holidays and insurance. The result of this recognition was a move by leading businesses to *impose* these features on their workforce—to outsource and casualize jobs, to group staff into teams working on finite projects, to equip them and expect them to take their work and job responsibilities home.

We might see these twin developments as the final 'instrumentalization' of the concept and the formation of the artistic avant-garde, a move beyond that co-option of them for commodification or cultural distinction that characterized the mid-twentieth century. Indeed in the defences made for continued investment in 'the creative industries' (investment rather than unconditional support, as befits an assumption of a profitable return), it is the economic argument alone that is normally made nowadays, as opposed to any emphasis on the humanistic or spiritual benefits of cultural practice and/or consumption in and of themselves. And on a global canvas, examples of the benefits of such investment are clearer than ever, from Bollywood film, through Korean computer games, to the international mushrooming of fine art museums—Bilbao, Rio de Janeiro, Taipei, to name but three—and of biennales and similar

exhibitions on every continent, serviced by a new profession of globetrotting 'über-curators'. It would seem that, of the two starting points of the idea of cultural avant-gardism from which we started, the ideas of Saint-Simon have won out, decisively, over those of Shelley: culture and the harnessing of the creative imagination are good (for) business.

Yet this judgement is too simplistic, for several reasons. First, as regards the creative industries' 'regeneration' agenda, we need to include the social benefits, as well as the economic, of harnessing avant-garde art practices; as the example of AIDS-related activism in New York showed, the institutions of the art world and of government are not solely co-optive but also supportive, and their participation is beneficial to such activism. Similarly, as regards the globalization of art and its museums, the spread of, say, biennale-type exhibitions can help to establish and develop communities of experimental artists, even those inclined to 'bite the hand that feeds them'. The expansion of the doyenne of all biennales, that of Venice, in the mid-1990s to invite young and post-colonial nations to send representatives is an example. The spate of exhibitions of contemporary African art from the same time (*Seven Stories* at London's Whitechapel Gallery in 1995, *Fault Lines* at Venice in 2003, *Africa Remix* that travelled from Düsseldorf to London, Paris, and elsewhere in 2007) is another. All of the latter encouraged, displayed, and documented the proliferation of contemporary experimental art in that diverse and complex continent, and brought to European attention a network of already-existing groups of self-consciously avant-gardist artists in, for instance, Senegal and the Democratic Republic of the Congo, some of who were engaged in social activism of a kind that paralleled the collectives of New York that I have mentioned.

Perhaps, then, we might see the contemporary forces in play in the shaping of the artistic avant-garde and the dissemination of it across the globe as comparable to that dynamic that I have traced in pre-First World War Europe: a moment in which a network of

experimental, self-consciously avant-gardist artists (in all media) sharing a sense of 'alternative professionalism' was built through the top-down and bottom-up actions of a multiplicity of participants and institutions. There certainly seem to be some similarities: the sense that western art forms not only still predominate outside of the west, but that status recognition of non-western artists (in all media) requires consecration in the western capitals, appears to reprise the obligation felt by the early twentieth-century avant-garde to pay homage to Paris despite wishing to pursue different agendas. Similarly the aspiration, consequent upon this tension, to strengthen 'South–South' cultural and institutional links across the world to offset the 'west and the rest' hierarchy reprises the energies that went into establishing rival cultural centres to Paris—Munich, Berlin, Vienna—before the First World War.

But there are also key differences. The avant-garde, both as a formation and as a concept, now has a history, as we have seen, and one that is integrally related to the spread of a capitalism, and especially a consumerism, that are far more developed, conglomerate, and all-encompassing than a hundred years ago. Moreover, that individual experimentalism and cultural entrepreneurialism which drove the ad hoc creation of the avant-garde network across Europe a hundred years ago is no longer possible—we could say that the avant-garde formation in the twenty-first century is thoroughly professionalized, and in ways that are no longer 'alternative' but normative for contemporary cultural practices. Equally crucially, the modernity of the contemporary world is plural—that is, there are modernit*ies*: as über-curator Okwui Enwezor suggests, the western model needs to be supplemented by at least three others, each of which stands for a distinct, and sometimes contestatory, 'take' on the processes of modernization by which the contemporary world has been shaped. In 2007 Enwezor curated the eleventh contemporary art exhibition in the series known as *Documenta* that is held in Kassel, in Germany, every four years; its

central theme was a sustained examination of shifting relationships between post-coloniality and neoliberalism, artistic activism and radicalism, and globalization and the 'historical avant-garde'. In presenting the exhibition, Enwezor asked: 'What is the fate of the avant-garde in this climate of incessant assault upon its former conclusions?' And he argued that 'while strong revolutionary claims have been made for the avant-garde within westernism, its vision of modernity remains surprisingly conservative and formal'. Enwezor concluded that there is a need to understand 'new relations of artistic modernity not founded on westernism'. What these might be, however, he was not telling.

Others have offered suggestions, though. In 1989 the Centre Pompidou in Paris mounted a huge multi-site exhibition called *Magiciens de la terre* (Earth's Magicians) that presented work by artists of all continents as variations on a shared sense of modernity and/or postmodernity. Since then, the world has changed. There is now emerging a broad recognition that in the face of the homogenizing forces of modern international capitalism, the attempts not only of a hundred, but of twenty-five, years ago on the part of non-western avant-gardist cultural groups and networks to frame their practices, in this way, in western terms are now futile. As a historian of contemporary African culture, Elizabeth Harney, argues, the avant-gardes of the present, in Senegal as elsewhere, should 'frame their interventions as critiques of neoliberal patronage'—should pick up the baton of the originary avant-gardist ideology and seek to legislate for their world. An example of such 'interventions' is the activity of the Senegalese arts collective Huit Facettes, which is made up of clergymen, lawyers and doctors, and other professionals as well as artists. It organizes workshops and lends artistic guidance to Senegalese villages, acting to develop economic opportunities for them where the state has failed, in the face of global economic pressures. In their own words, 'to create South–South work relations is the opportunity to have access to choices, in a world of history and geopolitics that belong to us'. Whether such an

avant-gardism can succeed and be sustained, in the face of those institutionalizing forces that have shaped the history of the avant-garde as a formation, and have defeated such initiatives in the past, remains to be seen. As ever, the nature of the phenomenon of the avant-garde in a global context seems fatally split between its potential and its practices.

Finally, let us return to a question with which I started: how does the concept of the avant-garde, its history, and that of the formation that carries its name help to understand the ways in which newness and up-to-dateness function in western societies (indeed, we can say globally)? It is evident that the idea of 'avant-garde' depends on the notion of progress: to be ahead of the rest, even in opposition to it, requires a belief in forward movement. But we (in the west at least) seem to have lost faith in this idea within the post-Second World War period. That is, since—when?—the end of the post-war boom in the mid-1970s, which brought to an end the most affluent period for western societies in the history of capitalism? Since the moment of a dawning awareness of the finitude of the planet's resources? The candidates for this tipping point, and the reasons for it, are several; but in each case it overlaps with the co-option of 'avant-garde' for market purposes, and the emptying from it of any more profoundly critical perspectives or alternative values. In the terms of Thomas Crow's argument that I outlined, the cultural avant-garde is thus now, practically speaking, merely the 'research and development arm' not only of the 'culture industry', but of consumerism in general.

But as I noted with respect to global modernities, the world has changed since 1989. In their book *Collectivism after Modernism* Blake Stimson and Gregory Sholette echo the opening declaration of the *Communist Manifesto* to argue that 'there is a spectre haunting capitalism's globalisation, the spectre of a new collectivism'. This, they say, has two aspects: 'the collectivism of public opinion rising and falling on the Arab street' and that of

'eBay, say, or Amazon...or of chat rooms and flashmobs and blogospheres and listservs'. Each of these is challenging the dominant order, and—as we have seen—with respect at least to the latter, the cultural activism that has inherited the ideology of avant-gardism is determined to make use of it. Elsewhere, Sholette adds a third collectivism: what he calls the 'dark matter' of the unofficial economy of occasional artists, informal systems of exchange, cooperative networks, and various hit-and-run ecopractices. And as art historian and theorist John Roberts notes, this is an informal economy that includes professional non-market artists and non-professional artists alike, in a growing matrix of socialized art activity that, albeit hidden to the market, now defines the terrain on which art is practised. 'For capitalism to acknowledge this missing mass', says Sholette, 'would require a radical re-definition of the concept of productivity' that could, at last, achieve that avant-gardist goal of bringing art and social life together, of the one changing the other—legislating for the world. I wouldn't bet on it doing so, though.

Further reading

There are so many books on the avant-garde, addressed to so many different aspects of it as well as depths of pocket, that the following suggestions for further reading on the subjects of each chapter is necessarily limited in its aims. My first aim is to give references for those authors and writings that I have specifically named in this book, to assist anyone who wishes to learn more about their ideas. The texts to which the reader is directed, in these cases, vary in their level of readability from the fairly introductory to the scholarly, and you must take each as you find it—though they are all useful contributions to our understanding of aspects of the concept of the avant-garde and/or of its history. My second aim is to suggest, for each chapter, a few accessible yet thought-provoking texts that develop or further explain aspects of it. Between them, these suggestions offer both a means to finding out more about what has interested you in particular, of the ideas I have discussed, and some starting points for following up the principal themes around which the makers, critics, theorists, and historians of the avant-garde have built their understanding of it.

Introduction

A landmark study, one of the first works to discuss the concept and history of the avant-garde, and still a useful and accessible starting point for serious study of it, is Renato Poggioli's *Theory of the Avant-Garde* (Harvard University Press, 1968). Also essential, but more recent, more wide-ranging, and updated since its first publication in 1977, is Matei Calinescu, *Five Faces of Modernity:*

Modernism, Avant-Garde, Decadence, Kitsch, Postmodernism
(Duke University Press, 1987/2006). On a more scholarly level,
Richard Murphy, *Theorizing the Avant-Garde: Modernism,
Expressionism and the Problem of Postmodernity* (Cambridge
University Press, 1998), is stimulating, and Dietrich
Scheunemann's edited multi-authored *European Avant-Garde:
New Perspectives* (Rodopi, 2008) contains a range of essays that
offer what the title promises. On art in New York after the Second
World War, David Joselit's *American Art since 1945* (Thames &
Hudson, 2003) is a lively introduction. On literary avant-gardes,
Pascale Casanova, *The World Republic of Letters* (Harvard
University Press, 2004) and Andrew Webber, *The European
Avant-Garde 1900–1940* (Polity, 2004) are valuable. On those in
twentieth-century music, Alex Ross, *The Rest Is Noise* (Fourth
Estate, 2008) is excellent, as is Greil Marcus's irrepressible, and
irreplaceable, *Lipstick Traces: A Secret History of the Twentieth
Century* (Harvard University Press, 1990).

Chapter 1 Origins: emergence and consolidation 1820–1914

Calinescu's *Five Faces of Modernity* (see above) is a key reference here.
On modernist art in the nineteenth century, T. J. Clark's *The
Painting of Modern Life: Paris in the Art of Manet and his
Followers* (Thames & Hudson, 1985) is a seminal work. Pierre
Bourdieu's ideas on the structure of the artistic field are in his *The
Field of Cultural Production* (Polity, 1993). On bohemia, Jerrold
Seigel's *Bohemian Paris: Culture, Politics and the Boundaries of
Bourgeois Life, 1830–1930* (Penguin, 1987) is essential reading.
Martha Ward, *Pissarro, Neo-Impressionism and the Spaces of the
Avant-Garde* (Chicago University Press, 1996) is invaluable on the
emergence of the formation in late nineteenth-century Paris; for
those who read French, Béatrice Joyeux-Prunel's pioneering
history of Parisian artists' networks in Europe c.1860–1914, *Nul
n'est prophète en son pays?* (Musée d'Orsay, 2009) is 'worth a
detour'. Robert Jensen's *Marketing Modernism in Fin-de-Siècle
Europe* (Princeton University Press, 1994) is similarly so for a
continent-wide perspective. On professionalization, Harold
Perkins's *The Rise of Professional Society: England since 1880*
(Routledge, 2nd edn. 2002) is a good starting point, and Francis
Haskell's edited, multi-author collection of essays in *The Authority
of Experts* (Indiana University Press, 1984) offers sociological

perspectives. Paul Wood (ed.), *The Challenge of the Avant-Garde* (Yale University Press, 1999) offers an excellent overview of the roles of Cubism and Futurism.

Chapter 2 Professionalisms and politics between the wars

On the inter-war groups of the Constructivist movement, the catalogue, edited by Gladys Fabre and Doris Wintgens Hötte, of Tate's exhibition *Van Doesburg and the International Avant-Garde* (2009) has some excellent essays. Marjorie Beale, *The Modernist Enterprise: French Elites and the Threat of Modernity, 1900–1940* (Stanford University Press, 1999) is fascinating on her subject. On his, Marc Dachy, *The Dada Movement 1915–1923* (Rizzoli, 1990) is comprehensive, and Maria Gough, *The Artist as Producer: Russian Constructivism in Revolution* (University of California Press, 2005) is ground-breaking. Romy Golan, *Modernity and Nostalgia: Art and Politics in France between the Wars* (Yale University Press, 1995) and Kenneth E. Silver, *Esprit de Corps: The Art of the Parisian Avant-Garde and the First World War, 1914–1925* (Thames and Hudson, 1989) are both essential on the 'call to order' in that country, and Mark Antliff, *Avant-Garde Fascism: The Mobilization of Myth, Art, and Culture in France, 1909–1939* (Duke University Press, 2007) is a valuable assessment.

Chapter 3 Consumerism and co-option

Stuart Hall's 'Notes on Deconstructing "the Popular"' is in Raphael Samuel (ed.), *People's History and Socialist Theory* (Routledge, 1981). On the early twentieth-century and inter-war avant-garde formation, Walter Adamson's *Embattled Avant-Gardes: Modernism's Resistance to Commodity Culture in Europe* (University of California Press, 2007) is stimulating and original. Tom Gunning's essay on 'The Cinema of Attractions', and other valuable essays on film history, are in Thomas Elsaessser and Adam Barker (eds.), *Early Cinema: Space, Frame, Narrative* (BFI, 1990). Thomas Crow's seminal essay 'Modernism and Mass Culture in the Visual Arts' can be found in Frascina, *Pollock and After: The Critical Debate* (Harper and Row, 1985). Pierre Bourdieu's analysis of intellectuals and popular culture is in his landmark volume *Distinction: A Social Critique of the Judgement of Taste* (Routledge, 1984). The huge catalogue, edited by Kirk

Varnedoe and Adam Gopnik, of the 1991 MoMA exhibition *High and Low: Modern Art and Popular Culture* (MoMA, 1991) is the most encyclopaedic of the many books on its subject. Bernard Gendron's *Between Montmartre and the Mudd Club: Popular Music and the Avant-Garde* (University of Chicago Press, 2002) is a pioneering history. Clement Greenberg's 'Avant-Garde and Kitsch' is reprinted in Francis Frascina (ed.), *Pollock and After* (see above).

Chapter 4 Avant-Garde and revolution

Raymond Williams's essay 'The Politics of the Avant-Garde' in his collection of essays *The Politics of Modernism: Against the New Conformists*, ed. Tony Pinckney (Verso, 1989), is essential reading. Paul Wood's 'Modernism and the Idea of the Avant-Garde', in Paul Smith and Carolyn Wilde (eds.), *A Companion to Art Theory* (Blackwell, 2002) is a valuable and perceptive overview. Clement Greenberg's 'Modernist Painting' is reprinted in Gregory Battcock (ed.), *The New Art: A Critical Anthology* (Dutton, 1973). Alan W. Moore's essay on 'Artists' Collectives' is in Blake Stimson and Gregory Sholette (eds.), *Collectivism after Modernism: The Art of Social Imagination after 1945* (University of Minnesota Press, 2007). Thomas Frank's *The Conquest of Cool: Business Culture, Counterculture, and the Rise of Hip Consumerism* (University of Chicago Press, 1997) is an entertaining and sharp analysis. Peter Bürger's *Theory of the Avant-Garde* in English translation (University of Minnesota Press, 1984) is an obligatory, if challenging, read; Benjamin Buchloh's review of it is in *Art in America*, November 1984, 20–1. Peter Wollen's essay on the Situationists in his book *Raiding the Icebox: Reflections on Twentieth-Century Culture* (Verso, 1993) is a succinct and perceptive overview of this history, while McKenzie Wark's *The Beach beneath the Street* (Verso, 2011) is a lively and sympathetic account of the same. Gavin Grindon's article 'Surrealism, Dada and the Refusal of Work: Autonomy, Activism and Social Participation in the Radical Avant-Garde' in *Oxford Art Journal*, 34: 1, 2011, 79–96 is original and valuable. Finally, Julian Stallabrass's *Internet Art* (Tate, 2003) is a path-breaking survey of new cultural territory.

Conclusion

On the creative industries, Andrew Ross's *Nice Work if you Can Get It: Life and Labour in Precarious Times* (New York University Press, 2009) is a lively and sharp critique of the phenomenon that places it in social and political context. Luke Boltanski and Eve Chiapello's *The New Spirit of Capitalism* (Verso, 2005) is a pioneering and seminal work on its subject. Okwui Enwezor's introduction to the catalogue of the Tate triennial exhibition *Altermodern* in 2009 presents his ideas about multiple modernities, while Elizabeth Harney's article on African avant-gardes, 'Postcolonial Agitations: Avant-Gardism in Dakar and London', in *New Literary History* (University of Virginia), Autumn 2010, 731–51, is an invaluable overview of the issues raised by globalization. Gregory Sholette's *Dark Matter: Art and Politics in the Age of Enterprise Culture* (Pluto Press, 2010) is a ground-breaking analysis of the potential of the marginal, oppositional collectivities whose emergence he charts, while John Roberts builds from this to propose a re-evaluation of the relation between the avant-garde and revolutionary politics in his challenging essay 'Introduction: Art, "Enclave Theory" and the Communist Imaginary', in *Third Text*, July 2009, 353–67.

Index

4'33" (Cage) 33

A

abstraction 48–9
absurdism 79
Académie Julian 42, 47
action painting 89
activism
 political 99–102, 108, 114–16
 social 108–9, 119
aesthetic principles 40–1
African culture 121
alienation, artists' feelings of 7
alternative professionaliism 17–18,
 39–44, 69
anarchism 99
Apollinaire, Guillaume 81–2
art
 experimental 119–20
 humour in 78–9
 inter-disciplinarity 43–4
 vs. literature 29–31
 politicization 96–7
 privatization 27–8
 for revolutionary gains 70–2
art dealers 50–1
art exhibitions 12–13, 26–8, 43,
 66–7, 103–4, 120–1

'art for art's sake' 100
art schools 30
Art Workers Coalition (AWC)
 107–8
artists, described as avant-garde 5,
 22–3
authoritarianism vs.
 libertarianism 23
autonomy 24
 vs. heteronomy 28–9
avant-garde vs. modernism 8–14
'Avant-Garde and Kitsch'
 (Greenberg) 90–1
Avant-Garde Diaries website 95
avant-gard*ism* 4

B

Baker, Josephine 87
Bakst, Leon 44
ballet 83, 87
Ballets Russes 43–4
Barr, Alfred H. 103–4, 105
Baudelaire, Charles 5–6, 14
Bauhaus 67–8
Beaton, Cecil 90–1, 93–4
bebop 89, 93

ONLINE CATALOGUE

Very Short Introductions

Our online catalogue is designed to make it easy to find
your ideal Very Short Introduction. View the entire collection
by subject area, watch author videos, read sample chapters,
and download reading guides.

ART HISTORY
A Very Short Introduction
Dana Arnold

This clear and concise new introduction examines all the major debates and issues using a wide range of well-known examples. It discusses the challenge of using verbal and written language to analyse a visual form. Dana Arnold also examines the many different ways of writing about art, and the changing boundaries of the subject of art history. This book explains how the traditional emphasis on periods and styles originates in western art production and the problems that can arise from this.

A wide variety of topics are exlored such as the canon of Art History, the role of the gallery, 'blockbuster' exhibitions, the emergence of social histories of art (Feminist Art History or Queer Art History, for example), the impact of photography, and the development of Art History using artefacts such as the altarpiece, the portrait, or pornography, to explore social and cultural issues such as taste, religion, and politics.

www.oup.com/vsi

MODERN ART
A Very Short Introduction
David Cottington

Public interest in modern art continues to grow, as witnessed by the spectacular success of Tate Modern and the Bilbao Guggenheim. This book offers information and ideas about modern art, while explaining its contemporary relevance and history. Cottington also focuses on interrogatting the idea of 'modern' art by asking questions such as: what has made a work of art *qualify* as modern (or fail to)? How has this selection been made? What is the relationship between modern and contemporary art? Is 'posmodernist' art no longer modern, or just no longer modernist'?

Cottington examines many key aspects of this subject, including the isse of controversy in modern art, from Manet's *Dejeuner sur L'Herbe* (1863) to Picasso's Les *Demoiselle*, and Tracey Emin's *Bed*, (1999).

POSTMODERNISM
A Very Short Introduction
Christopher Butler

Postmodernism has become the buzzword of contemporary society over the last decade. But how can it be defined? In this Very Short Introduction Christopher Butler lithely challenges and explores the key ideas of posmodernism, and their engagement with literature, the visual arts, film, architecture, and music. He treats artists, intellectuals, critics, and social scientists' as if they were all members of a loosely constituted and quarrelsome political party' – a party which includes such members as Jacques Derrida, Salman Rushdie, Thomas Pynchon, David Bowie, and Micheal Craig-Martin – creating a vastly entertaining framework in which to unravel the mysteries of the 'postmodern condition', from the politicizing of museum culture to the cult of the politically correct.